Toulouse-Lautrec in The Metropolitan Museum of Art

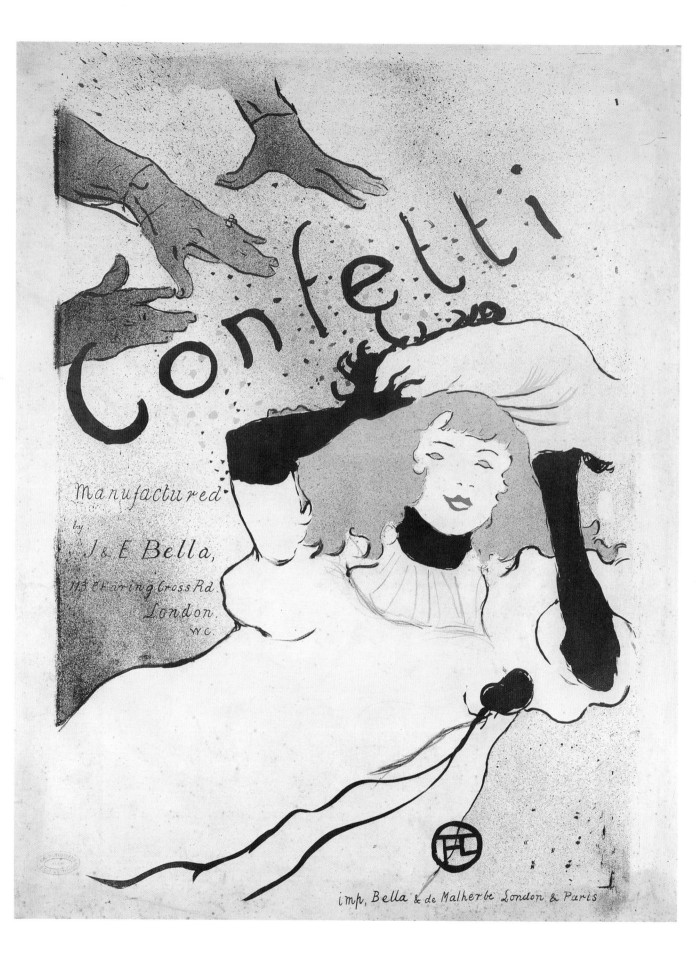

Toulouse-Lautrec

in The Metropolitan Museum of Art

Colta Ives

with a foreword by Philippe de Montebello

The Metropolitan Museum of Art

New York

Sponsor's Statement

Citibank is proud to sponsor The Metropolitan Museum of Art's exciting celebration of Henri de Toulouse-Lautrec. An artist of superb talent, Toulouse-Lautrec viewed the performers and patrons of Parisian night-life with a sharp and discerning eye for their character. His innovations in color lithography and graphic design created a new branch of art that was bold and lively—remarkably ahead of its time.

Citibank, with a long-standing tradition of innovation and exceptional performance in financial services, is pleased to support this outstanding exhibition. On such an occasion we are delighted to be able to contribute to the enrichment of New York's cultural life.

We hope you enjoy the exhibition "Toulouse-Lautrec in The Metropolitan Museum of Art."

Willy Socquet
Business Manager
New York Consumer Bank
Citibank

This publication is issued in conjunction with an exhibition held at The Metropolitan Museum of Art, New York, July 2–September 29, 1996.

The exhibition is made possible by **CITIBANK**.
The exhibition is also supported by the generosity of Janice H. Levin.

Published by The Metropolitan Museum of Art, New York
John P. O'Neill, Editor in Chief
Barbara Burn, Executive Editor
Margaret Aspinwall, Editor
Tsang Seymour Design Studio, Designer
Chris Zichello, Production
Robert Weisberg, Computer Specialist

All photographs of works in the Museum's collection are by the Photograph Studio, The Metropolitan Museum of Art. New photography was done by Katherine Dahab, Eileen Travell, and Anna-Marie Kellen.

Cover: *Detail of fig. 57*, MADEMOISELLE MARCELLE LENDER, EN BUSTE, *1895. Bequest of Scofield Thayer, 1982 (1984.1203.161)*
Frontispiece: CONFETTI, *1894. Poster, color lithograph; 568 x 445 mm. Gift of Bessie Potter Vonnoh, 1941 (41.12.42)*

Printed by Meridian Printing Company, East Greenwich, Rhode Island

Library of Congress Cataloging-in-Publication Data

Ives, Colta Feller
 Toulouse-Lautrec in the Metropolitan Museum of Art / Colta Ives.
 p. cm.
 Includes bibliographical references.
 ISBN 0-87099-804-8
 1. Toulouse-Lautrec, Henri de, 1864–1901—Exhibitions. 2. Art—New York (State)—New York—Exhibitions. 3. Metropolitan Museum of Art (New York, N.Y.)—Exhibitions. I. Toulouse-Lautrec, Henri de, 1864–1901. II. Metropolitan Museum of Art (New York, N.Y.) III. Title
N6853.T6A4 1996
760'.092—dc20 96-17722
 CIP

Contents

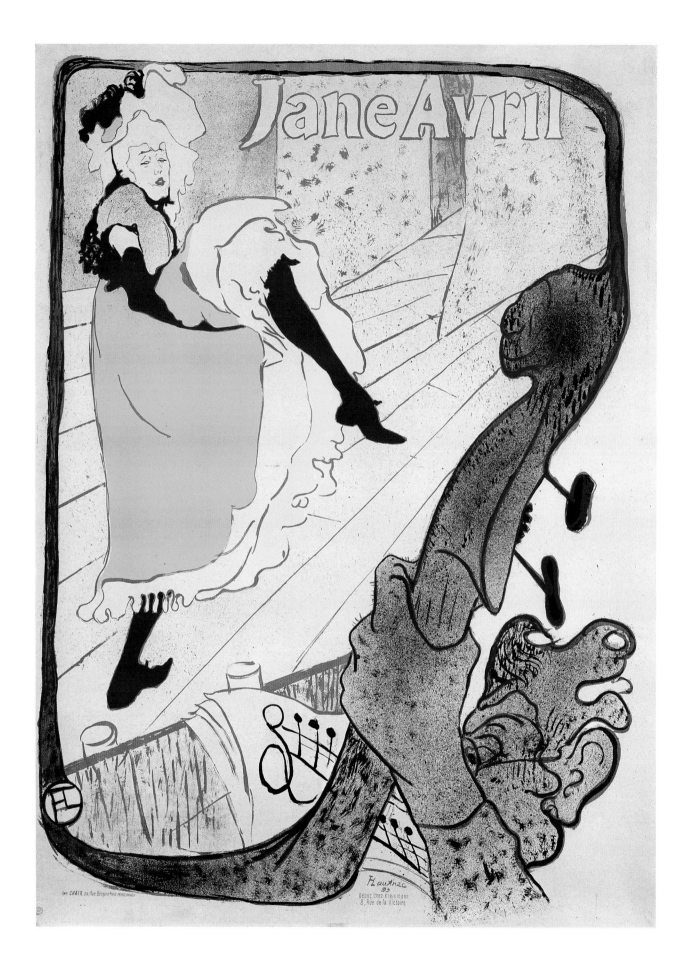

Director's Foreword

The Metropolitan Museum has in its collection an exceptional body of art in a range of media by the late-nineteenth-century French artist Henri de Toulouse-Lautrec. In exhibiting a large portion of these works, the Metropolitan once again invites the visitor—and the reader of this accompanying catalogue—to examine the product of a single fertile, inventive, and tireless mind through the rich veins of material housed at the Museum. The exhibition also gives us the chance to reassess this body of work in terms of recent scholarship. Additionally, since much of Toulouse-Lautrec's work is on paper and can be exhibited for only intermittent and limited periods of time, this show has given us an opportunity to examine these works from the point of view of conservation. Indeed, as it turned out, a number of the works on paper underwent extensive treatment before going on view.

The Museum's collection of art by Toulouse-Lautrec, the result largely of generous donations from private collectors, includes paintings, drawings, and examples of his finest and most important prints. The artist excelled in lithography; a hundred years ago his bold, persistent experimenting gave this medium an entirely new appearance just when the centennial of its invention was being marked in Europe. In fact, with the wealth of examples at the Metropolitan Museum, we now can celebrate the bicentennial of lithography through the works of Toulouse-Lautrec, the artist who virtually reinvented this medium.

We are extremely grateful to Citibank for its sponsorship of this exhibition. We would also like to thank a dear friend to the Metropolitan Museum, Janice H. Levin, for her generous assistance.

I extend grateful acknowledgment to Colta Ives for her superb work in organizing the exhibition, on relatively short notice, and preparing the catalogue, which present the Museum's collection of Toulouse-Lautrec's work so lucidly. Others deserve thanks as well: Gary Tinterow and Susan Alyson Stein; George Goldner, David del Gaizo, Henrietta Susser, Calvin Brown, and Jennifer Winn; Laurence B. Kanter; Marjorie Shelley, Margaret Lawson, and Akiko Yamazaki; John O'Neill, Margaret Aspinwall, Patrick Seymour, and Chris Zichello; Barbara Bridgers; Michael C. Batista and Jill Hammarberg; Deborah Roldán.

Philippe de Montebello
Director

Fig. 1. JANE AVRIL, *1893. Poster, color lithograph; 1290 x 935 mm. Harris Brisbane Dick Fund, 1932 (32.88.15)*

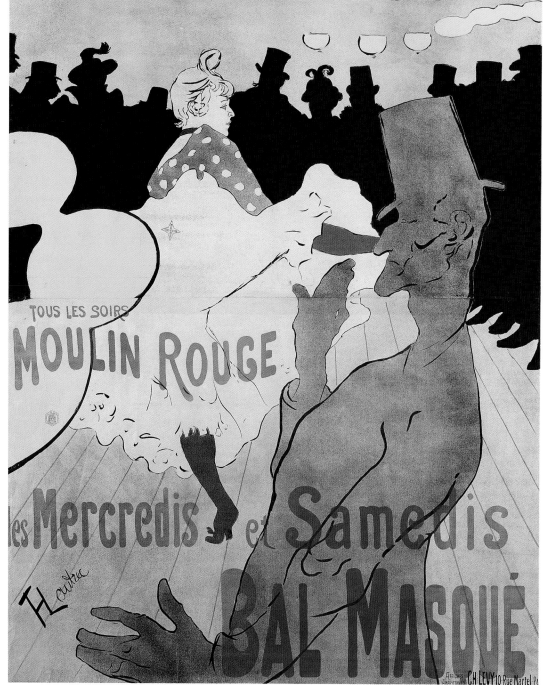

Toulouse-Lautrec

An Introduction

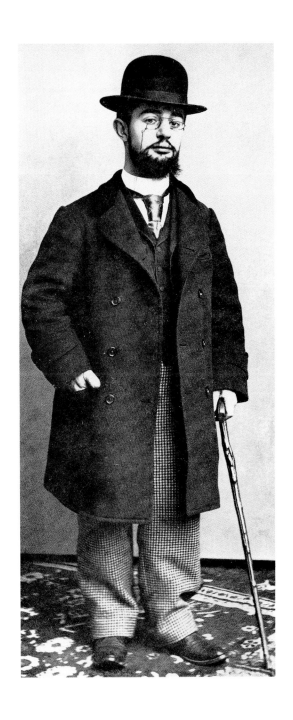

Although Lautrec's professional career lasted little more than a decade, both the artist and his works have long enjoyed widespread renown. The disproportionate shape of Lautrec himself, his abbreviated life, and his vivid art seem to have been designed to mesmerize us. Who could have encountered the tragicomic Lautrec without staring, or approached his brash pictures without stopping to take them in?

Lautrec's notoriety has proven both a blessing and a curse. For the artist, who never outgrew a childish exhibitionism, it was a kind of balm. Perpetually calling attention to his ungainly person and to his uncouth production, he seems to have been taking revenge on a world that had cruelly assigned him the role of the dwarfed alcoholic son of old French aristocracy. His high birth, keen intelligence, and stunning artistic genius could never quite be reconciled with his physical handicaps: "I will always be a thoroughbred hitched up to a rubbish cart," he said (quoted in Frey 1994, p. 378).

The special quality of Lautrec's achievement is only rarely realized in occasional exhibitions and is made all the more difficult to appreciate because of the numbing multitudes of poor-quality reproductions and copies of his best-known works which have been circulated since their creation. It was, in fact, almost exactly one hundred years ago that Lautrec was at the height of his power, the most vehement historian of life in Paris's

Facing page: *Fig. 2.* MOULIN ROUGE: LA GOULUE, *1891. Poster, color lithograph; 1900 x 1165 mm. Harris Brisbane Dick Fund, 1932 (32.88.12)*

Fig. 3. Toulouse-Lautrec, with his cane, 1892. Photograph. Musée de Toulouse-Lautrec, Albi

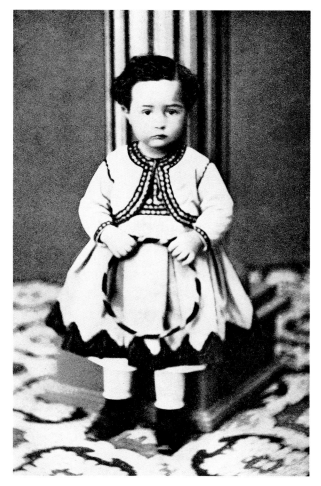

Bohemian district of Montmartre. Midget king of the hill, or at least a court jester, he was, all the same, a determined and industrious artist. It was not without enormous effort that he succeeded in immortalizing the dance halls and shabby cabarets of his neighborhood, the star performers and the down-at-the-heels streetwalkers who posed as his models. Lautrec's life in the forced jollity of Montmartre somehow suited his crippled being and inspired him to devise an art so discordant that it was in perfect harmony with his bizarre existence.

Born twenty-five years after the invention of photography, Lautrec is the first important artist for whom there exists a photographic history. Studio

Fig. 4. Henri de Toulouse-Lautrec at the age of three or four. Photograph. Musée de Toulouse-Lautrec, Albi

Fig. 5. The Château du Bosc, family residence north of Albi, near Naucelle, Aveyron. Photograph. Musée de Toulouse-Lautrec, Albi

portraits taken of him and of people close to him, as well as snapshots recounting antics with friends, provide a striking reflection of the artist's life that is further enhanced by quantities of surviving letters and memoirs. These documents make it clear that Lautrec's singular origins determined the unusual shape of his art.

A descendant of one of the oldest and most prestigious French families which had ruled the regions of Toulouse and Aquitaine for centuries, Lautrec was born in 1864 to first cousins; his younger brother died in infancy. He inherited his father's eccentricity, his mother's acute sensitivity, and from their union, a genetic disorder that mercilessly thwarted his physical

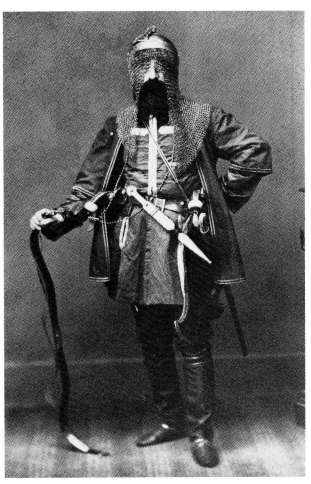

Fig. 6. Alphonse de Toulouse-Lautrec (Henri's father) dressed in Circassian chain mail. Photograph. Bibliothèque Nationale, Paris

Fig. 7. Henri de Toulouse-Lautrec with Louis Anquetin and René Grenier on an outing. Photograph. Musée de Toulouse-Lautrec, Albi

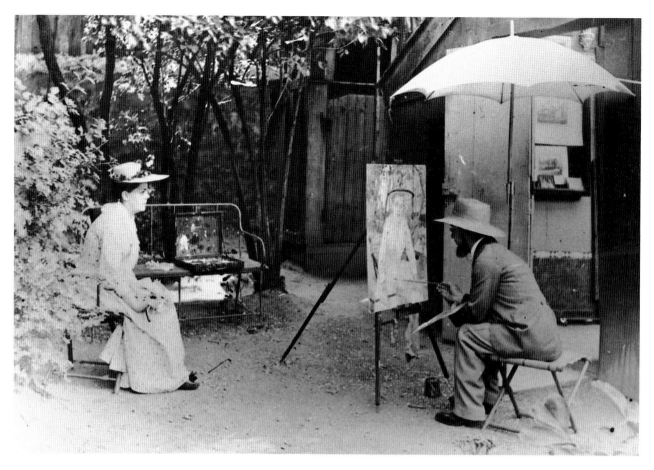

Fig. 8. Toulouse-Lautrec painting WOMAN *[Berthe la sourde]* WITH AN UMBRELLA IN FOREST'S GARDEN, *1889 (private collection). Photograph by Maurice Guibert. Musée de Toulouse-Lautrec, Albi*

development. Until he was about eleven or twelve years old, Henri seems to have been a normal, healthy child, actively pursuing the expected pastimes in family châteaux and hunting lodges, playing with costumes, at drawing, and with dogs, birds, and "le sport" of horses. However, his naturally high spirits and wit were soon called upon to mask the discomfort of sore joints, cramps, and other pains associated with his stymied growth. "I would have had a bully good time but those cursed toothaches made me see everything crooked," he once reported after a childhood outing; and later, poignantly, when his poorly developing bones began to trouble his walking, "If I could leave my legs here, and go off in an envelope (just to give you and Maman a kiss) I would do it" (quoted in Frey 1994, pp. 59, 65).

After Lautrec broke both legs in minor falls at the ages of fourteen and fifteen, his growth became further stunted. He reached his full height at four feet, eleven inches, and often was forced to walk with a cane. The genetic disorder from which he (and three cousins who were even more severely dwarfed) suffered manifested itself also in chronic headaches and sinus trouble which caused his lisping speech to be interrupted by sniffles. With so many health problems, young Henri concentrated on favorite activities that could be pursued from a bed. His unathletic maternal uncle Charles helped him with drawings and watercolors, and even when he was mobile he hardly went anywhere without his paint box.

Lautrec passed a peripatetic youth, traveling with his mother between family houses in the region of Toulouse and hotels in Paris, with frequent stays at special clinics and spas where it was hoped his condition might be improved. His parents evidently viewed his sustained passion for making pictures as little more than a useful hobby which filled his days and distracted him from his handicaps. Supported by the family's ample wealth but ill-equipped to follow the professions that were then acceptable for gentlemen (in diplomacy, the military, or estate management), Lautrec allied himself

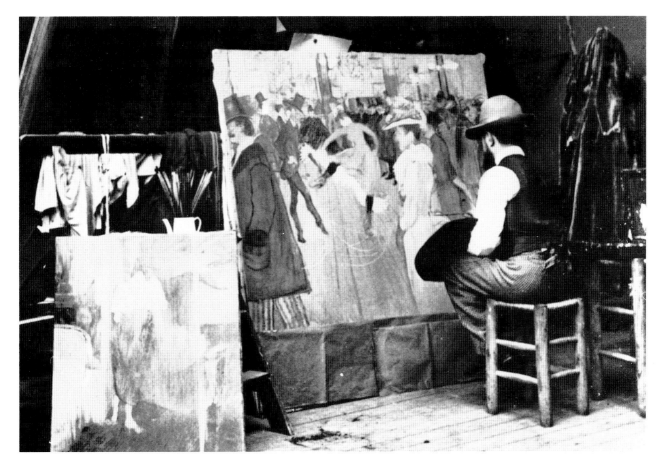

Fig. 9. Toulouse-Lautrec painting THE DANCE AT THE MOULIN ROUGE: TRAINING THE NEW GIRLS, *1889–90 (Philadelphia Museum of Art). Photograph. Musée de Toulouse-Lautrec, Albi*

with two painters—his uncle Charles and the deaf-mute René Princeteau, an expert in horses whom his father befriended—and set about turning himself into a painter.

Once he had achieved his baccalaureate degree, Lautrec was allowed to enter the studio of the painter Léon Bonnat, whom his parents deemed acceptable by dint of his advantaged birth in Bordeaux (he was thus a native of their own region) and his success as a society portraitist. The same cautious criteria applied when Lautrec enrolled with his second teacher, Fernand Cormon, a history painter. From 1882 to 1884, he took a horse-drawn cab every morning from the fashionable and moneyed rue du Faubourg Saint-Honoré, where he shared rooms with his mother, to the proletarian streets of Montmartre. Thus transported to another world entirely, he copied plaster casts and drew live models under the watchful eyes of his instructors.

The young students at the easels near Lautrec's were also influential in his development, particularly Emile Bernard, Louis Anquetin, and Vincent van Gogh, who came to work at Cormon's in 1886. By that time Lautrec had set up his own studio in Montmartre and was rebelling, along with his student-colleagues, against the rules of realistic art. His preferences ran to the art of Manet, Degas, and the Impressionists, prompting him to try his hand at plein air painting in a neighbor's garden, where he took models whom he had hired locally (see figs. 8, 28). From that time on his art became focused on the people and activities of his Bohemian neighborhood, where the nightclubs and cabarets not only enlivened his social life, but more importantly, fueled his art.

A devil-may-care attitude now came to govern virtually all his actions, and Lautrec opened himself to an increasing range of possibilities. Like many of his young artist friends, he believed devoutly in the enlargement of art's role and the expansion of its audience. Thus, in 1886 he began to issue drawings that were printed in newspapers and magazines like *Le*

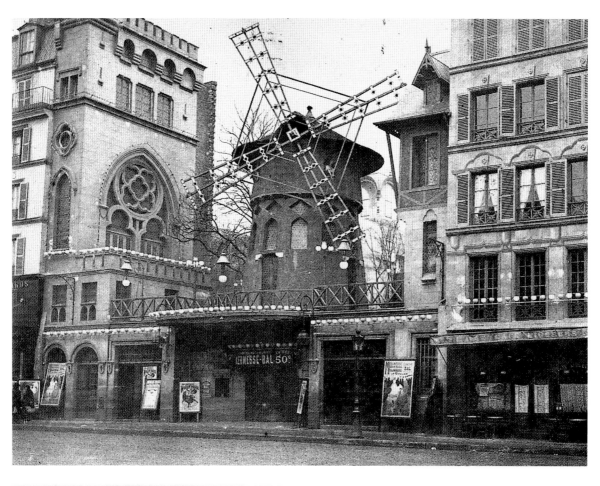

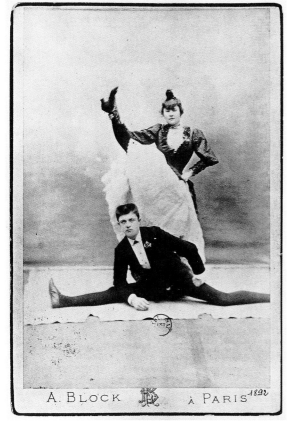

Fig. 10. The Moulin Rouge on the boulevard de Clichy, Paris, with Lautrec's posters stationed out front. Photograph. Bibliothèque Nationale, Paris

Fig. 11. La Goulue and Valentin le Désossé, 1892. Photograph by A. Block. Bibliothèque Nationale, Paris

Courrier Français and *Le Mirliton*; these were followed by assignments to design the covers of sheet music, theater programs, print portfolios, and paperbound books. In oversize paintings (see fig. 9), Lautrec dramatically shunned convention, aggrandizing the stars of the circus and of the working-class dance halls as if they were the equals of heroes portrayed in history murals.

Proud to be at a remove from his melancholy, protective mother and out and about on his own, Lautrec quite readily abandoned aspirations for the kinds of recognition most artists craved: admission to the Ecole des Beaux-Arts, the award of a Prix de Rome, and the acceptance of works for display in the official Salon exhibitions. (In 1887, under a pseudonym, he jokingly submitted to the Salon jury a hastily painted

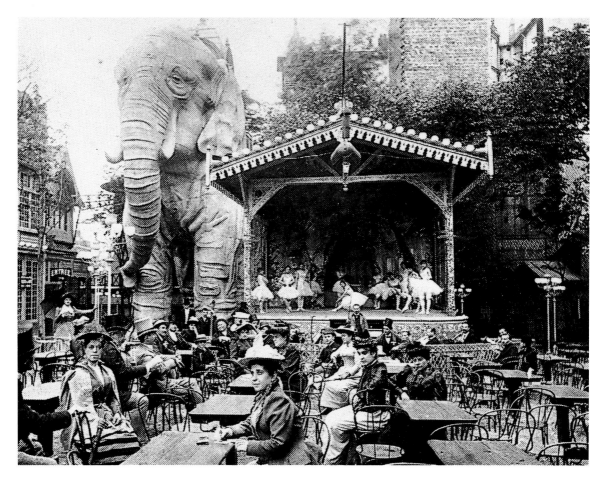

still life of a Camembert cheese which, naturally, was rejected.) He now ridiculed Cormon's laborious assignments in the perfection of mythological and biblical figures, which he had once patiently completed, and opted instead to portray informally his friends and colorful acquaintances, painting them with thinned oils on bare cardboard or raw canvas.

Montmartre, haven for outcasts and a newfound center for populist sentiments, embraced Lautrec and other sons of the privileged classes who were on the outs with their upbringing. Its nightspots offered rowdy entertainment in an authentically vulgar atmosphere that was crowded with thugs and shopgirls, day laborers and prostitutes. When the brassy dance hall and drinking garden of the Moulin Rouge (fig. 10) opened on the boulevard de Clichy in 1889, one of Lautrec's most recent and innovative paintings, *The Bareback Rider at the Fernando Circus,* which had been purchased by Joseph Oller, one of the nightclub's owners, was displayed near the entrance. Soon the artist himself became a conspicuous fixture, seated most nights with his friends at a front-row table in the gaslit hall or garden, where a huge papier-mâché elephant

saved from the 1889 Exposition Universelle housed a small orchestra (fig. 12).

During the next seven or eight years, Lautrec produced thirty paintings of the Moulin Rouge and its regulars, the first of which, *The Dance at the Moulin Rouge,* 1889–90 (see fig. 9), sparked the commission for the six-foot-tall poster (figs. 2, 10) that launched his printmaking career and made him famous overnight. His friend Thadée Natanson later commented that a poster should be like a "fist in the face" (quoted in Frey 1994, p. 294), an opinion Lautrec's striking design might well have provoked. Instead of depicting a sugary poster girl like the ones who beckoned from the billboard prints of Jules Chéret (founding father of street advertising), the novice Lautrec turned a spotlight on the crowded dance floor of the Moulin Rouge and its star performers, the "boneless" acrobat Valentin le Désossé and La Goulue, "the glutton," whose cancan skirts were lifted to reveal her bloomer-clad backside which was regularly

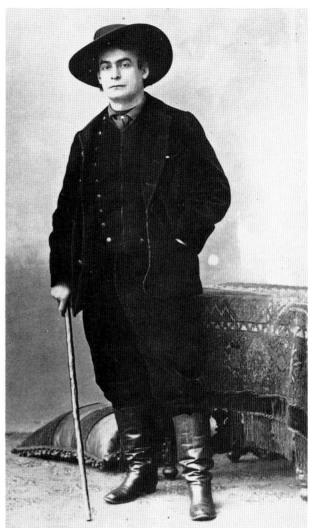

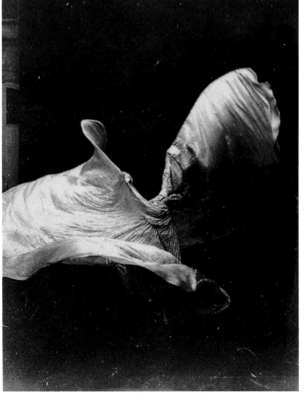

Fig. 13. Publicity photograph of Jane Avril dancing, ca. 1893

Fig. 14. Aristide Bruant, ca. 1886. Photograph by Atelier Nadar. Bibliothèque Nationale, Paris

Fig. 15. Loïe Fuller. Photograph. Bibliothèque Nationale, Paris

cheered at the finale of the *chahut* (see figs. 2, 11).

It was from this explosive public debut which, predictably, outraged his family, that Lautrec went on to become the decade's greatest commercial artist and promoter of Parisian nightlife, a genius in the practice of color lithography, with which he created more than three hundred prints, filling albums or portfolios for collectors; enlivening books, magazines, playbills, and song sheets; and seizing the eyes of Parisians as they hurried along boulevards and streets.

Sometimes it was a performer or a cabaret that commissioned a work for publicity, but usually Lautrec's

Fig. 16. Yvette Guilbert, ca. 1894. Photograph by Chalot-Camus. Bibliothèque Nationale, Paris

Fig. 17. May Belfort. Photograph. Ludwig Charell Archive, The Museum of Modern Art, New York

irresistible attraction to a particular singer or dancer motivated his pen or crayon. From a barstool, theater seat, or beer-hall bench, he studied each performer, capturing Loïe Fuller's billowing skirts (figs. 15, 43), Jane Avril's fluttering steps (figs. 1, 13, 40), Aristide Bruant's knowing scowl (figs. 14, 36, 38), Yvette Guilbert's black-gloved arms (figs. 16, 61–64), and May Belfort's childish pouts and curtsies (figs. 17, 23, 50–52). Compared to their electrifying portrayals at the hands of Lautrec, the stars, when encountered in camera-made pictures, look rather tame and lackluster. The artist, who controlled ridicule of himself by playing the clown (fig. 18), readily identified with performers and thus could convey the postures, gestures, and facial expressions that create the dynamic of theatrical performance with convincing gusto. Magnifying his favorites' quirks, which he publicized in loud, brassy designs and in rapid scrawls, he made them appear larger than life.

Produced at a time when moviemaking was born (the first public film showing in Paris occurred in 1895), Lautrec's works seem to predict Hollywood's style of publicity, geared for immediate recognition and wide distribution, with occasional doses of shock appeal.

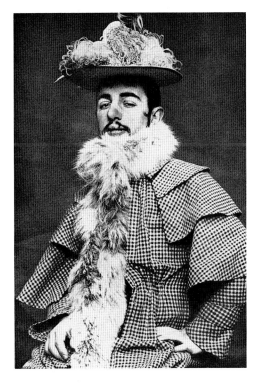

Fig. 18. Toulouse-Lautrec wearing Jane Avril's feathered hat and boa, ca. 1892. Photograph. Musée de Toulouse-Lautrec, Albi

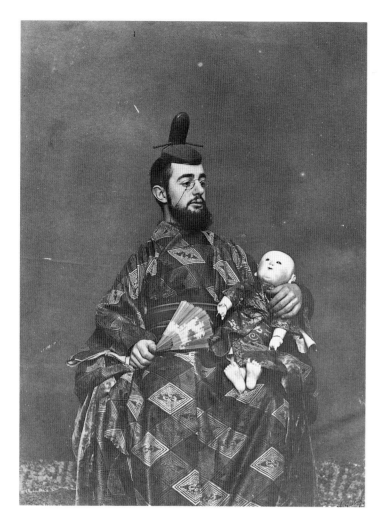

Fig. 19. Maurice Guibert. HENRI DE TOULOUSE-LAUTREC DRESSED IN JAPANESE COSTUME, *ca. 1890s. Gelatin-silver print, 351 x 261 mm. The Museum of Modern Art, New York; Anonymous gift. Copy print © 1996 The Museum of Modern Art*

Lautrec himself never lost sight of the fact that the artistic medium that brought him fame was identified with advertising, for whenever he publicized a star, he publicized his own artistry, and as it happened, he was seldom more effective than when he mixed his acerbic genius with lithographic ink. The decade of the 1890s was the golden age of color lithography, the artistic argot of the time, and an avenue to recognition traveled also by Bonnard, Vuillard, and other young avant-garde artists who were eager to overreach Impressionism. Their impulse toward contemporaneity and simplicity was very strong, and like the poets of Symbolism, these artists felt they could express more if they used less— provided they were excruciatingly selective. Fewer forms, fewer colors, and less modeling led to abstraction and flattened space in their pictures, rather like the art of medieval times or exotic places.

Lautrec had inherited a love of things foreign from his father, the second comte Alphonse (fig. 6), who might sling a Japanese sword at his side while he sported a Buffalo Bill hat and a coat of mail. Henri, too, delighted in the trappings of other periods and climes. There are photographs of him disguised as a Pierrot and a choir-boy; at least two camera portraits show him in daimyo robes (see fig. 19).

A wave of foreign bibelots had flooded France after trade agreements reached in 1855 reopened the ports of Japan which had been sealed for two centuries. After Lautrec saw a large exhibition of Japanese art at the Galerie Georges Petit in 1883, he began building his own collection of *japoneries.* By 1890, when a staggering show of more than a thousand ukiyo-e color woodcuts was mounted at the Ecole des Beaux-Arts in Paris, he had already broken with academic realism and his early tight, impressionist manner to ally his art with that of van Gogh and the Japanese. Indeed, the principles of ukiyo-e prints virtually defined his refurbished style, especially as it was employed in his poster designs which were constructed of curvaceous forms, expressively outlined and filled in with bright, flat colors. Moreover, as

Fig. 20. Toulouse-Lautrec and friends in the garden of the Moulin de la Galette. Photograph. Bibliothèque Nationale, Paris

his signature Lautrec had devised a monogram HTL enclosed in a circle that was surely derived from the circular seals Japanese artists and publishers applied to their prints and which Lautrec had spent hours learning to read and reproduce.

In the choice of subjects that he depicted, as much as the way he portrayed them, Lautrec further connected his work to that of ukiyo-e artists, who extolled such transient pleasures as "singing songs, drinking wine . . . and floating . . . ," pastimes that could be enjoyed in the entertaining Yoshiwara district of Edo (Tokyo), as they could in the streets of Montmartre.

Like the eighteenth-century Japanese master Utamaro, whose woodcut series of courtesans, such as *The Twelve Hours of the Green Houses* (ca. 1795), were admired by Edmond de Goncourt, Mary Cassatt, and Degas, Lautrec too moved into "green houses," where he observed women bathing, dressing, and combing their hair. But the Frenchman understood the basic differences between exquisitely trained, educated

geishas and Parisian prostitutes; he did not try to imitate Utamaro's elegant ladies with their swanlike necks and elaborate coiffures, but presented his own world-weary models with a mischievous nonchalance that bordered grotesque. Lautrec took perverse pride in exhibiting his peep shows of his "second" existence, often to precisely the people he expected would disapprove, tossing in an aside about the brothels, as if by way of explanation, "They're the only places in Paris where you can still get a good shoeshine" (quoted in Frey 1994, p. 345).

In truth, however, Lautrec never had to look far for either male or female company. His outrageous, self-deprecating humor and sheer intelligence generally overcame the initial qualms of acquaintances. Thadée Natanson, publisher of the journal *La Revue blanche*, once remarked that Lautrec's observations on Balzac were exceeded in their acuteness only by those of Proust, and were "more profoundly human." While Natanson's wife, Misia, whose first reaction to the artist was to look the other way, soon managed to ignore his

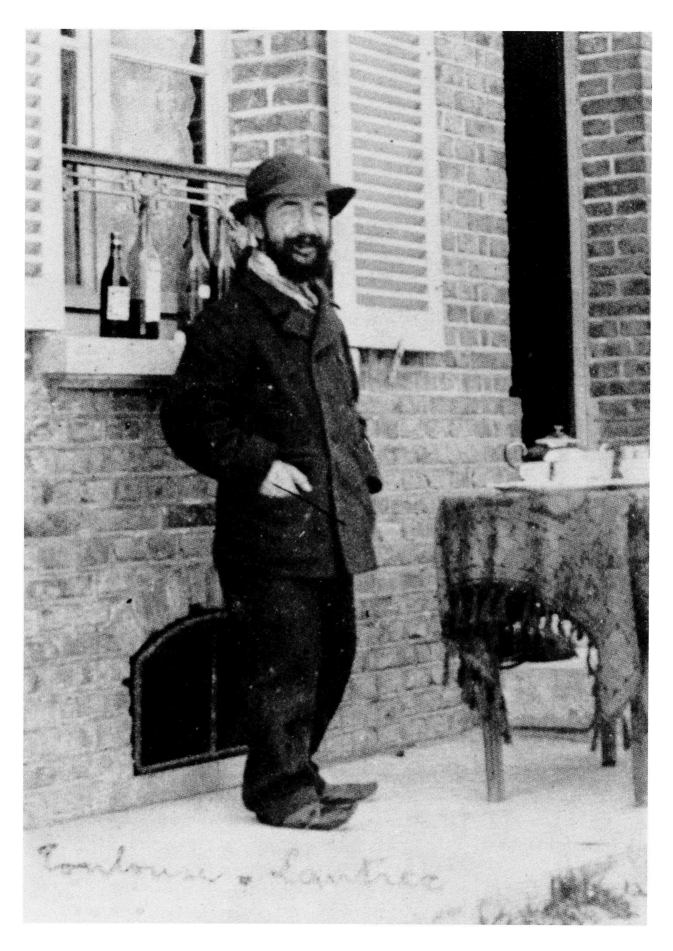

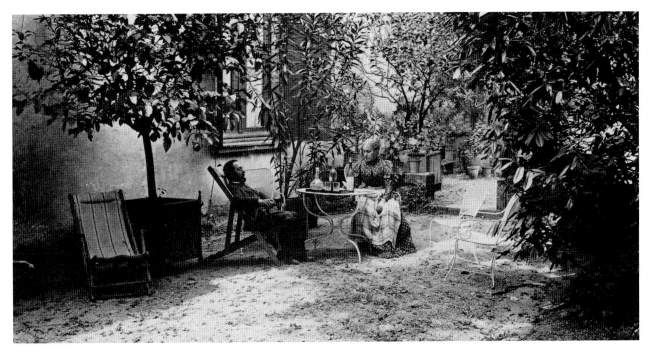

Fig. 22. Toulouse-Lautrec and his mother in the garden of the Château de Malromé, near Bordeaux, ca. 1895. Photograph by Maurice Guibert. Bibliothèque Nationale, Paris

distressing appearance and the painful way he dragged himself along with his cane. "We didn't even hear him sniffle any more," she recalled. "We saw only his eyes, glowing with wit and tenderness, and sometimes a flash of anger" (quoted in Frey 1994, pp. 332, 334).

Exhibitions of his paintings and prints mounted in galleries and artists' group shows in Paris, Brussels, and other nearby cities were generally well received, and a stream of regular commissions evidenced his success, but Lautrec's decadent lifestyle put him on the path to self-destruction. At twenty-four, he had said, "I expect to burn myself out by the time I'm forty" (quoted in Frey 1994, p. 242). His prediction was not far off the mark, but slightly optimistic.

Lautrec's obvious gifts as an artist and unmistakable talent for making friends were nonetheless insufficient to alleviate his discomfort. In order to treat the pain and frustrations he encountered simply maneuvering through the day, alcohol, very early on, became routine medicine. The enormous disparity between his polite,

privileged background and the questionable company in which he currently mixed created difficulty on all sides. His parents' misgivings were expressed by a stinginess that kept him in financial straits, and the fact that his father sold to other family members the large properties that should have been his only child's inheritance could only have reassured Henri that he did not count. He closed himself more and more with uncontrolled drinking, which he laughed off as he did his deformity. "No, I'm not afraid of getting falling-down drunk," he reportedly said. "After all, I'm so close to the ground" (quoted in Frey 1994, p. 244).

Lautrec was dead in 1901, at the age of thirty-six, after a hospital confinement to treat a "madness" exacerbated by alcohol and syphilis. His short, brilliant career fizzled out like spent fireworks. Having taken what he did to such extremes, he had no real followers, aside from—momentarily—the young Picasso, whose Catalan home neighbored Toulouse and who arrived in Paris shortly before Lautrec died.

Fig. 21. Toulouse-Lautrec at Le Crotoy, on the Normandy coast, ca. 1900. Photograph. Bibliothèque Nationale, Paris

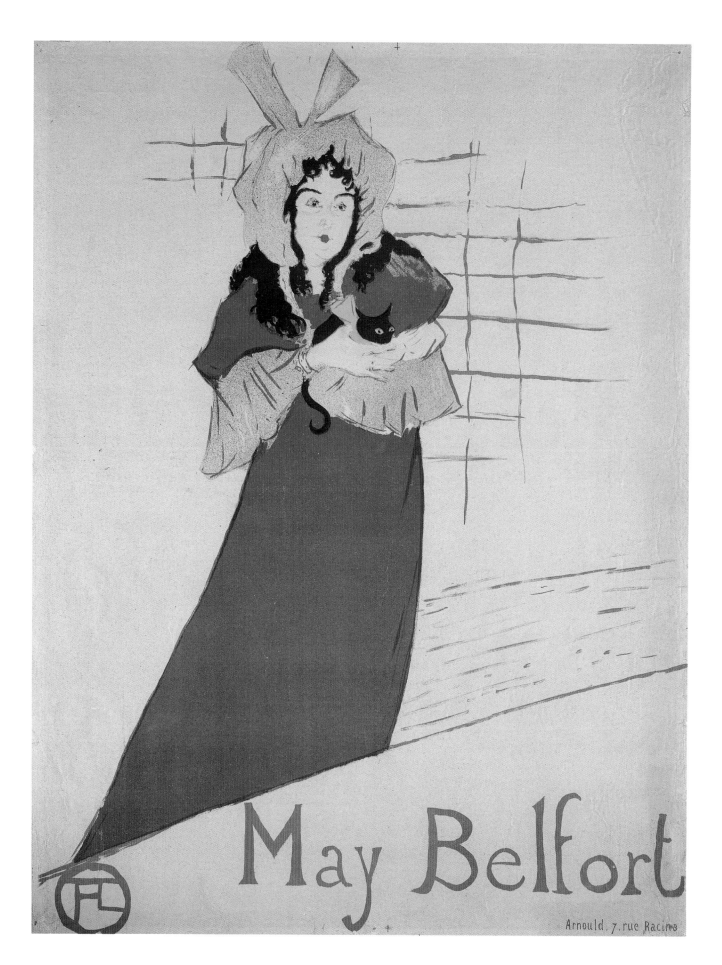

Arnould, 7, rue Racine

The Museum's Collection

Principal Works

Among the very finest collections of Lautrec's work outside Paris and Albi, France, the Metropolitan Museum's holdings include more than two hundred paintings, drawings, and prints. The collection is remarkably comprehensive, representing the full range of the artist's activity in virtually all stages and techniques, and is notable for both its qualitative and quantitative richness.

Because Lautrec's fame was transported first and farthest by his bold colored prints, these were the Museum's earliest acquisitions. In 1917, only a few months after the Department of Prints was founded, his 1898 portfolio of lithographed portraits of Yvette Guilbert was made a gift. During the following year, when Lautrec's earlier (1894) suite featuring Mlle Guilbert was bought, a vigorous program of purchases commenced. Between 1922 and 1932, the Museum bought twenty-nine portfolio prints and posters (eleven in 1932 alone), including the artist's first, largest, and most famous lithograph for the Moulin Rouge and nine other now-rare billboard advertisements. After that, the Lautrec print collection was enlarged principally through gifts from the American sculptor

Bessie Potter Vonnoh (1941), and the bequests of Alfred Stieglitz (1949), Clifford A. Furst (1958), and Scofield Thayer (1982). Both Stieglitz and Thayer had played important roles in bringing Lautrec's work to the attention of Americans during the 1910s and 1920s, the photographer through his avant-garde gallery "291," and the publisher through his magazine, *The Dial*.

The broad range of paintings and drawings by Lautrec in the Museum is surprising since these collections were started so late. After *The Sofa* was purchased in 1951, works arrived intermittently by gift and bequest, notably with Adelaide Milton de Groot's bequest in 1967 of the oil sketch *The English-man at the Moulin Rouge*, and in 1975, with the receipt of the colored chalk drawing *At the Circus: The Spanish Walk* from the Robert Lehman Collection, and *Woman in the Garden of Monsieur Forest,* the bequest of Joan Whitney Payson. It is much more recently, with the installation in 1992 of three splendid works from the Annenberg Collection, that a balance in our holdings has been reached, so that Lautrec's role as a painter might achieve the proper emphasis.

Fig. 23. MAY BELFORT, *1895. Color lithograph; 800 x 615 mm. Gift of Bessie Potter Vonnoh, 1941 (41.12.1)*

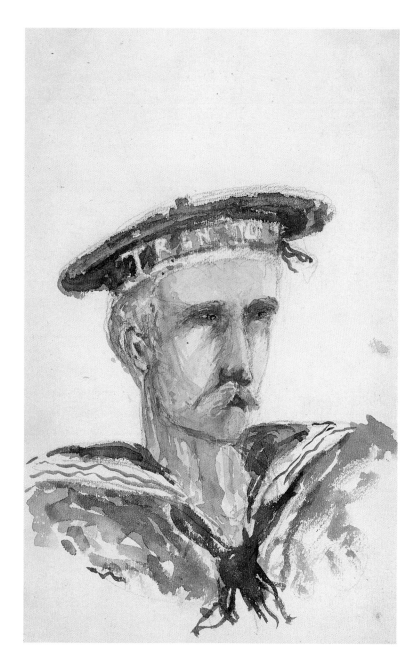

Fig. 24. [Sailor], folio in ALBUM DE MARINE, *1879–80.*
Watercolor and black chalk; 150 x 235 mm. Bequest of
Clifford A. Furst, 1958 (58.130)

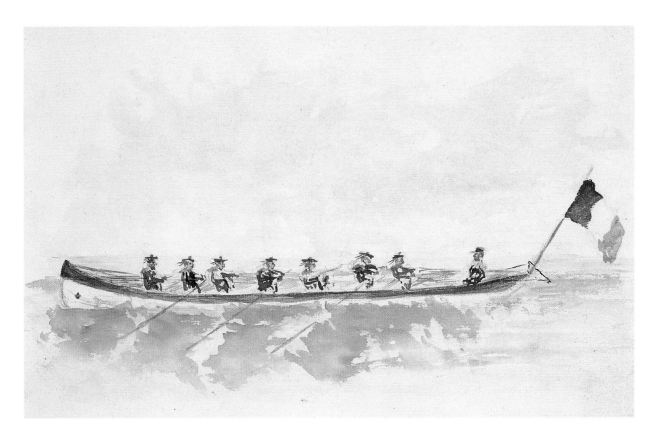

By the time he was three, Lautrec had already been
dubbed "a great sketcher" by his grandmother Gabrielle,
who noted proudly, "we consume quantities of paper
and pencils." Later, when problems of health often
confined his activity, he took pleasure in lessons his
uncle Charles gave him in drawing and painting with
watercolors.

Among the many childhood sketchbooks he filled
with drawings of his father's horses, hunting dogs, and
other varied subjects is this one, which fifteen-year-
old Henri carried with him in 1879 when he and his
mother visited the Mediterranean coast near Nice.
The arrival in the harbor of an American frigate under
full sail stirred Henri into a frenzy of drawing boats
and sailors, followed by his adoption of a new hobby—
building model ships.

The faces of people who amused or were dear to him were always at the center of Lautrec's art. It was as if by portraying them, he drew them closer and made them uniquely his. In addition to a large production of paintings in oil and gouache, over three thousand sketches survive in which Lautrec grasped the salient features of someone who, perhaps only briefly, caught his eye, like Joret (fig. 26) with his wild hair and handlebar mustache.

Lautrec became friends with René Grenier (fig. 27) in the atelier of Léon Bonnat in 1882, and later the two became students of Fernand Cormon. Since Grenier came from the district of Toulouse and was well-to-do, he was considered a worthy companion for her son by Lautrec's protective mother. Thus, before establishing his own quarters in the rue Caulaincourt in 1886, Lautrec lived with René and Lili Grenier, both of whom occasionally posed for him. Their apartment at 19 bis rue Fontaine was a gathering place for many of the young artists in their circle, and it was there that Lautrec encountered the older and aloof Degas, who kept a studio on the ground floor and living quarters on the fourth.

Lautrec's sensitive and affectionate portrait of Grenier combines the naturalism that both artists had been trained to master, with an irrepressible inclination toward the loosened brushstrokes of Impressionism. Like Vincent van Gogh, also a student in Cormon's studio, Lautrec forged his style in rebellion against academic norms. Early in 1887, several months after their first meeting, Lautrec made a portrait of van Gogh in short, complementary-colored pastel strokes that followed both the Dutchman's style and the explorations of Seurat.

Fig. 26. THE CLOWN: M. JORET, *1885. Pen and black ink; 127 x 102 mm. Gift of Mr. and Mrs. Justin K. Thannhauser, 1951 (51.180)*

Fig. 27. ALBERT (RENÉ) GRENIER *(1858–1925), 1887. Oil on wood; 340 x 254 mm. Bequest of Mary Cushing Fosburgh, 1978 (1979.135.14)*

Fig. 28. WOMAN IN THE GARDEN OF MONSIEUR FOREST. *Oil on canvas; 556 x 464 mm. Bequest of Joan Whitney Payson, 1975 (1976.201.15)*

Between 1889 and 1891 Lautrec often posed models in the garden of his Montmartre neighbor Père Forest, a retired photographer. After working diligently in the studio all morning, the painter took afternoons out of doors, evidently to practice the style of Impressionism that had been elevated to sumptuous negligence in the late works of Manet.

We scarcely know the names of the local shop-girls and streetwalkers (preferably redheads) whom Lautrec engaged to sit for him. Among them was one called "Casque d'Or" (fig. 29), whose hair (or wig) was knotted up in the coiffure made fashionable by the dancer La Goulue. Known to have been the submistress of a brothel on the rue des Rosiers, the pallid Miss "Golden Helmet," brought into the bright glare of daylight, stares owl-like. Akin to Lautrec, she is an odd bird dropped into an exotic setting.

Fig. 29. THE STREETWALKER. *Oil on cardboard; 648 x 533 mm. Anticipated Bequest of Walter H. Annenberg*

Although he never tired of making pictures of his friends, Lautrec had neither the patience, nor the proper attitude to maintain a career as a professional portraitist. Like Ingres, he was apt to lavish attention on the expressive features of a sitter's face and then rather abruptly scrawl in a few notes suggesting the rest of the figure's form. Around the time he sketched Mlle Nys (fig. 30) for her family, well-meaning friends tried to help Lautrec secure important portrait commissions, but society women, who seemed at first fascinated by such a prospect, soon fled in dismay from their sittings, after suffering insult.

In 1893, the year Lautrec painted his cohort the artist Henri Ibels (fig. 31), the two were preparing portraits of Parisian entertainers for a portfolio of prints, *Le Café Concert* (see figs. 36 and 40). Two years before, they had shown their work together at the gallery Le Barc de Boutteville.

A boon companion to Lautrec, like him full of mischief and bravura, Ibels often drew upon the life of the working classes for illustrations he printed in the popular press. In satirical prints he tweaked the noses of the bourgeoisie.

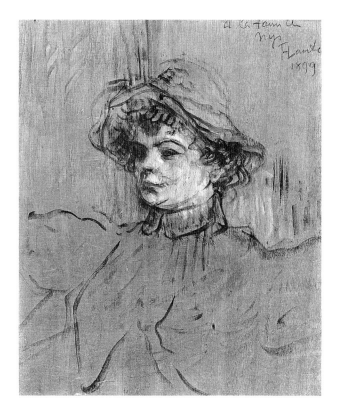

Fig. 30. MADEMOISELLE NYS, *1899. Oil on unprimed wood; 270 x 219 mm. The Lesley and Emma Sheafer Collection, Bequest of Emma A. Sheafer, 1973 (1974.356.36)*

Fig. 31. HENRI-GABRIEL IBELS *(1867–1936), 1893. Gouache on paper; 521 x 394 mm. Anticipated Bequest of Walter H. Annenberg*

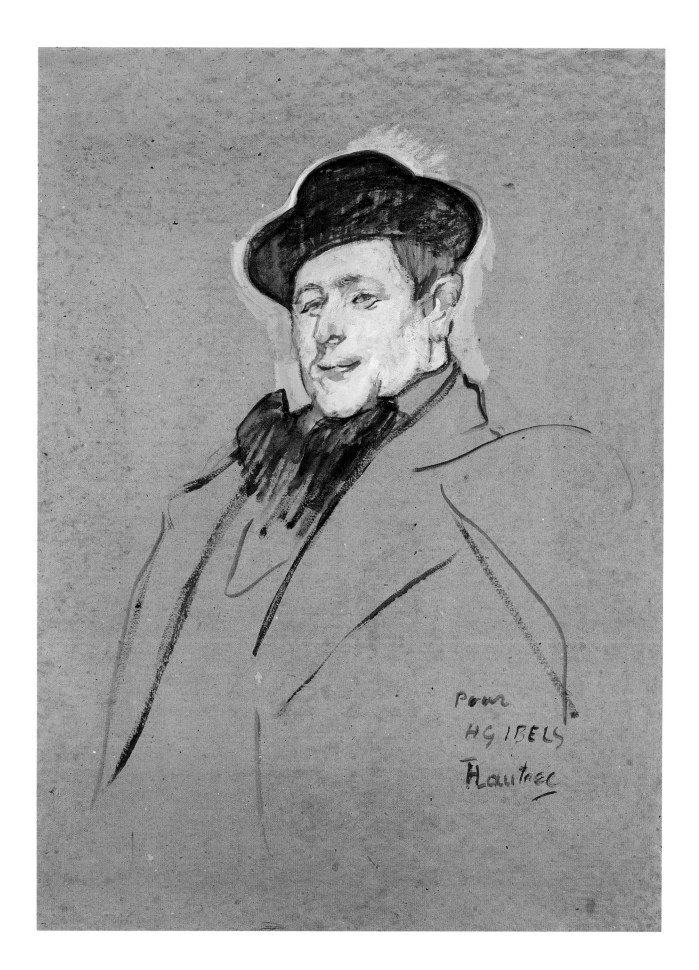

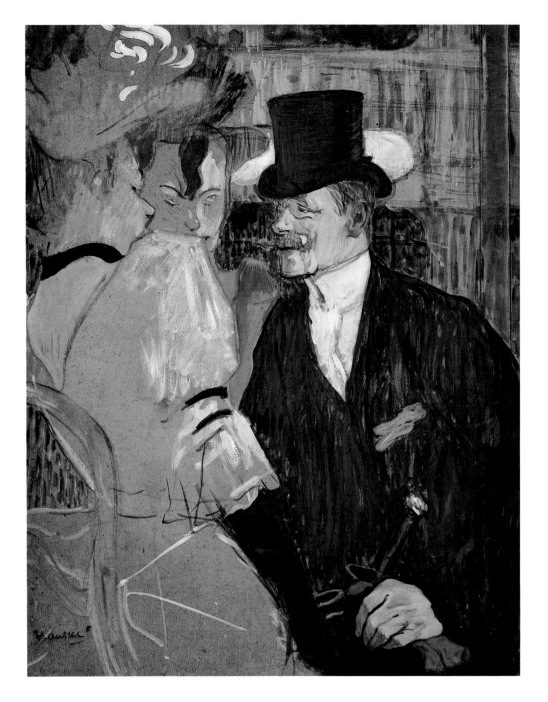

Fig. 32. THE ENGLISHMAN AT THE MOULIN ROUGE,
1892. Oil and gouache on cardboard; 857 x 660 mm.
Bequest of Miss Adelaide Milton de Groot (1876–1967),
1967 (67.187.108)

The Moulin Rouge offered its bar, drinking garden,
and Montmartre's most raucous entertainment to a
clientele mixed of the chic and the seedy, the well-
mannered and the gross. Among them was the
English painter William Tom Warrener, the top-hatted

gentleman seen here, blushing at the risqué remarks
of two of the nightclub's dancers, Rayon d'Or and
La Sauterelle. The girls' lips are discreetly concealed
behind a gigot sleeve, but Warrener's reddened ear
(evident in Lautrec's oil sketch, fig. 32, at first entitled
Flirt) gives the clue to his discomfort.

Pairing this preliminary painting with the subse-
quent print (fig. 33) helps to demonstrate Lautrec's
keen understanding of color lithography's virtues. His
conversion of this composition from painterly realism
to decorative abstraction was brilliantly achieved.

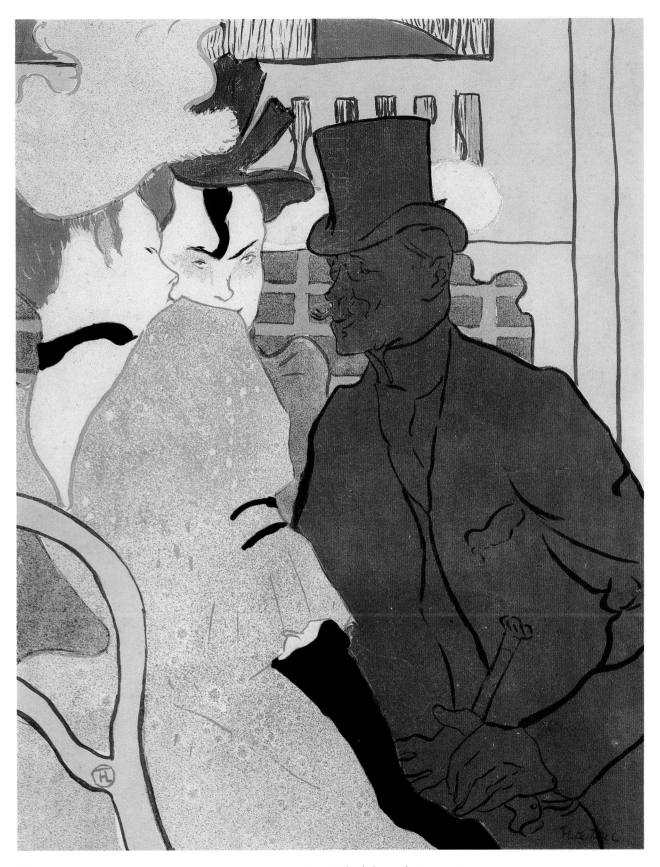

Fig. 33. THE ENGLISHMAN AT THE MOULIN ROUGE, *1892. Color lithograph; 600 x 480 mm.*
Bequest of Scofield Thayer, 1982 (1984.1203.139)

Lautrec studied the Japanese woodcuts that were tacked to the walls of van Gogh's room at 54 rue Lepic, and purchased ukiyo-e prints from the picture dealer Portier, who lived in the same building. Sometimes he managed to trade his own paintings for the woodcuts of Hokusai, Hiroshige, Utamaro, Toyokuni, and Kiyonaga.

Indeed, it was Lautrec's overwhelming fascination with Japanese color woodcuts that inspired the vivid abstraction that supplants Impressionism in his grandest color prints. Ukiyo-e actor portraits like those of Sharaku offered the exaggerated vulgarity that charged Lautrec's portrayals of the colorful regulars at the nightclubs of Montmartre.

Sharaku simplified and distorted the faces of his subjects unmercifully, prompting Lautrec to imagine the music-hall performers he knew as if they had been recast in some Kabuki drama with the attendant makeup, smart costumes, and lurid grimaces.

Fig. 34. Tōshūsai Sharaku (active 1794–95). THE ACTOR OTANI ONIJI III AS EDOHEI. *Color woodcut, mica ground; 381 x 251 mm. The Metropolitan Museum of Art; Henry L. Phillips Collection, Bequest of Henry L. Phillips, 1939 (JP 2822)*

Fig. 35. AT THE MOULIN ROUGE: LA GOULUE AND HER SISTER, *1892. Color lithograph; 461 x 348 mm. Gift of Bessie Potter Vonnoh, 1941 (41.12.18)*

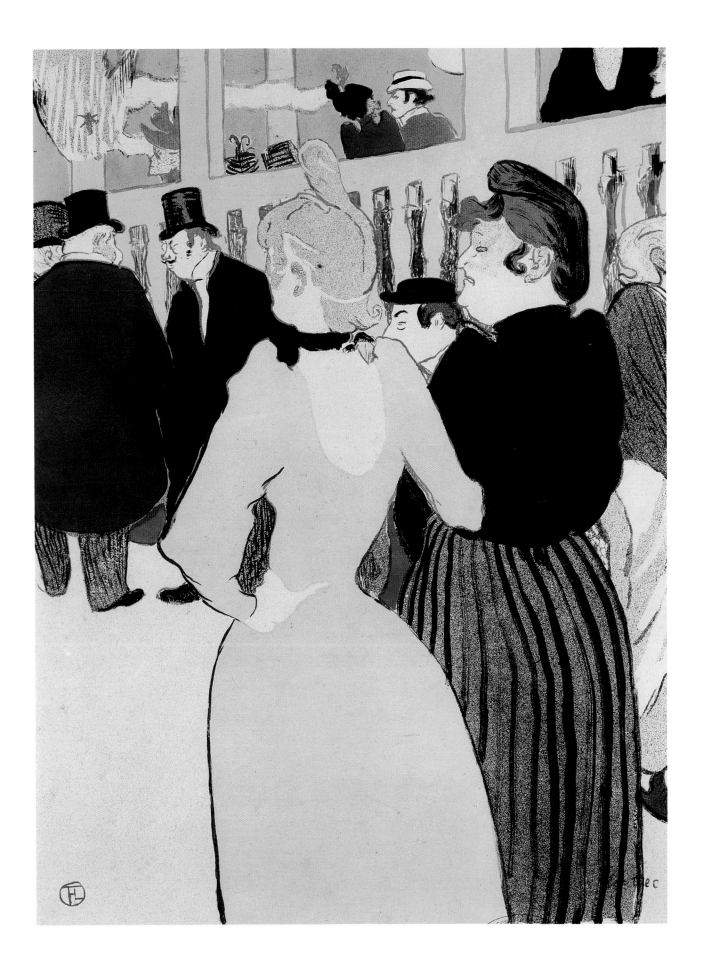

Fig. 36. ARISTIDE BRUANT, *1893. Plate 7 in the series* LE CAFÉ CONCERT. *Lithograph; 440 x 320 mm. Harris Brisbane Dick Fund, 1923 (23.30.3[7])*

Fig. 37. Katsukawa Shunshō (1726–1792). THE ACTOR ICHIKAWA DANJURO V IN A *SHIBARAKU* ROLE, *ca. 1781. Color woodcut; 329 x 140 mm. The Metropolitan Museum of Art; Purchase, Joseph Pulitzer Bequest, 1918 (JP 344)*

Lautrec was so often seated on the rough benches of the cabaret Le Mirliton that its owner Aristide Bruant sometimes introduced him from the stage. A tall, charismatic figure, ill-tempered and deliberately insulting, Bruant brayed out immensely popular songs that sympathetically addressed the miseries of life in Paris's prisons and slums.

Lautrec contributed illustrations to Bruant's magazine, also called *Le Mirliton* (toy whistle, or doggerel verse), and designed covers for his song sheets. In striking posters, Lautrec promoted the fame of the scowling Bruant seen costumed as a Bohemian artist, his name emblazoned across the back of his cape in bold calligraphy designed to give his advertisement thrust.

Fig. 38. ARISTIDE BRUANT, DANS SON CABARET *(Aristide Bruant, [Performing] at His Cabaret), 1893. Poster, color lithograph; 1380 x 990 mm. Harris Brisbane Dick Fund, 1932 (32.88.17)*

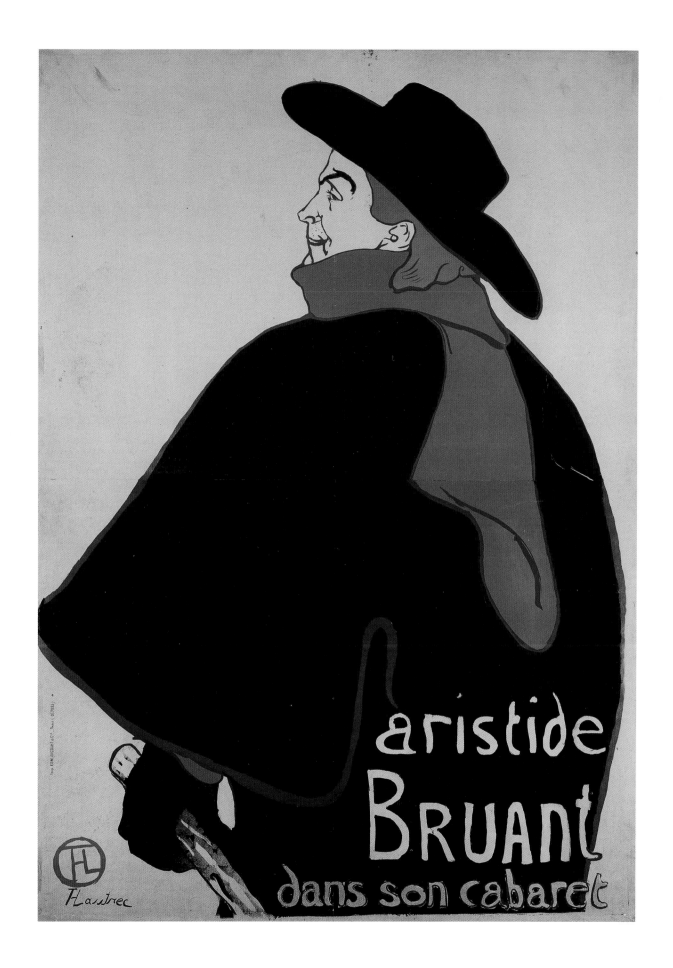

The Divan Japonais (Japanese Settee), a long and narrow café concert on the rue des Martyrs, tried to capitalize on the fashionable oriental mode. Its walls were hung with bazaar-quality silks and fans; the waitresses dressed in kimonos. According to one of its stars, Yvette Guilbert, the audience was mostly painters, sculptors, and writers—"Brilliant Bohemia!" But it was the claustrophobic mustiness of the place that seems to have impressed Lautrec and which reverberates in his 1892/93 poster showing his friends Jane Avril, the dancer, and Edouard Dujardin, the music critic, seated at the bar and listening to song- stress Guilbert, her head unexpectedly lopped off at the top of the poster.

Degas's art, which Lautrec admired greatly, probably deserves credit for the unusual cropping here, for the disembodied conductor's arms and the necks of viols waving from the orchestra pit, and for the descriptive role of the stage lights. Typically, Lautrec exaggerated all these elements. It is no doubt to Japanese woodcuts that he owed the total effect of flat, colored masses and lively outlines pressed into an airtight composition.

The jigsawed silhouette of Jane Avril, her plumed black hat, and the curious little handbag at her side (a comic stand-in for her friend Lautrec?) are blatantly decorative, situated in the tilted perspective of ukiyo-e woodcuts, where depth is described solely by the relative sizes of things or by perspective lines rushing to the picture's corners.

Until the 1890s, French posters were composed almost entirely of the primary colors: red, yellow, and blue. Lautrec introduced a brand new range of hues: purples, oranges, and greens that he achieved by layering colors printed from four, five, or even more lithographic stones. As if to reverse the direction of the Impressionists' palette, which added white to brighten views of the out-of-doors, Lautrec evidently added black in order to render night scenes in interiors which were often only dimly lit. Not entirely by accident, the aniline mauves, citrons, and absinthe greens he employed express the anxious, often sordid mood of Montmartre life.

Fig. 39. DIVAN JAPONAIS, *1892/93. Poster, color lithograph; 808 x 608 mm. Bequest of Clifford A. Furst, 1958 (58.621.17)*

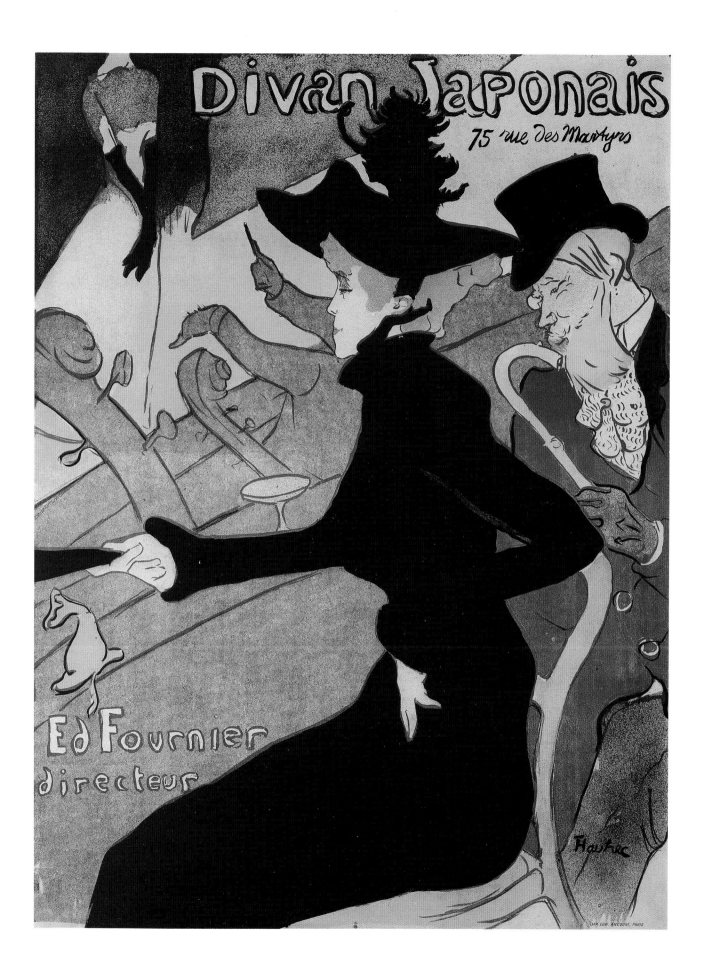

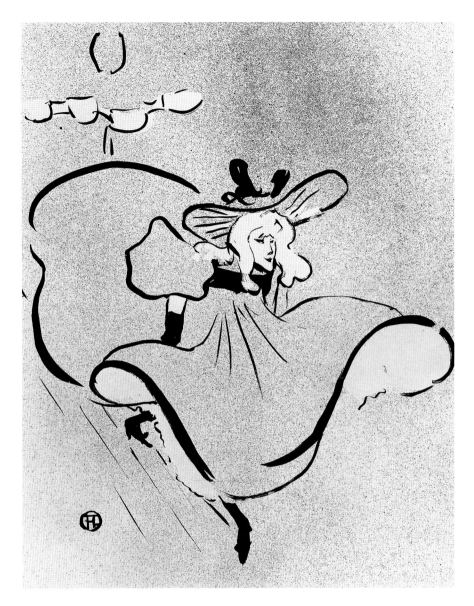

Fig. 40. JANE AVRIL, *1893. Plate 1 in the series* LE CAFÉ CONCERT. *Lithograph; 445 x 314 mm. Harris Brisbane Dick Fund, 1923 (23.30.3[1])*

Lautrec's earliest lithographs (through 1893) show his preference for lithographic ink over crayon, which he used with greater regularity later. The fluid outlines that describe the colored forms in his posters are a kind of decoration in themselves, like oriental calligraphy, or the vining line of Art Nouveau. They are essential to his composition's dynamic and its structure, as the leading is in stained-glass windows, the cloisons in fine enamels, or the key blocks in ukiyo-e woodcuts.

Lautrec, who had ordered a Japanese ink stone, sumi stick, and brushes especially from Japan, practiced his draftsmanship by drawing ink-brush sketches in the manner of Hokusai. His mastery of this mobile technique is amply displayed in the line and spatter lithograph that captured Jane Avril's floating footsteps across the floor of the Moulin Rouge (fig. 40). The tall Botticelli-like redhead would seem to have been an unlikely companion for Lautrec, but past traumas and like sentiments secured their lasting friendship.

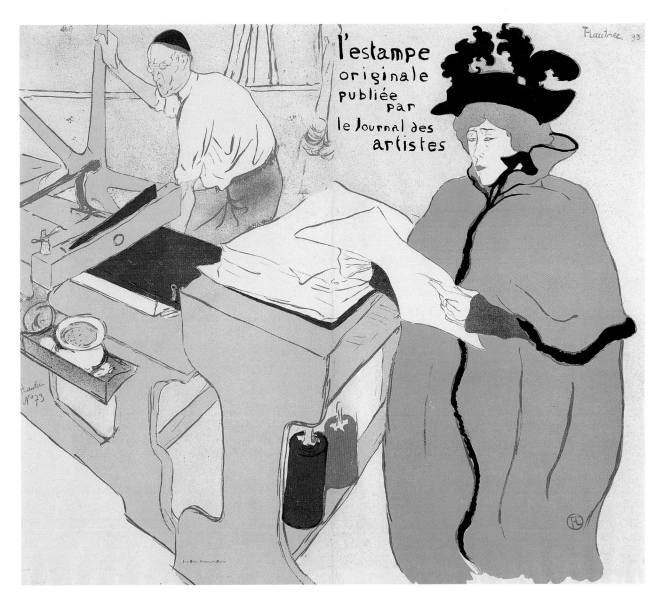

Fig. 41. L'ESTAMPE ORIGINALE, PUBLIÉE PAR LE JOURNAL DES ARTISTES, *1893. Cover for a portfolio of artists' prints. Color lithograph; 584 x 828 mm. Rogers Fund, 1922 (22.82.1[1])*

There may indeed have been several occasions when Miss Avril accompanied Lautrec to the shop of the publisher Ancourt, where the aged printer Père Cotelle pulled proofs for the artist's examination (fig. 41). Lautrec showed remarkable discipline where lithography was concerned. Although his nights were invariably long and bibulous, he often arrived at the printshop early in the morning to oversee the editions.

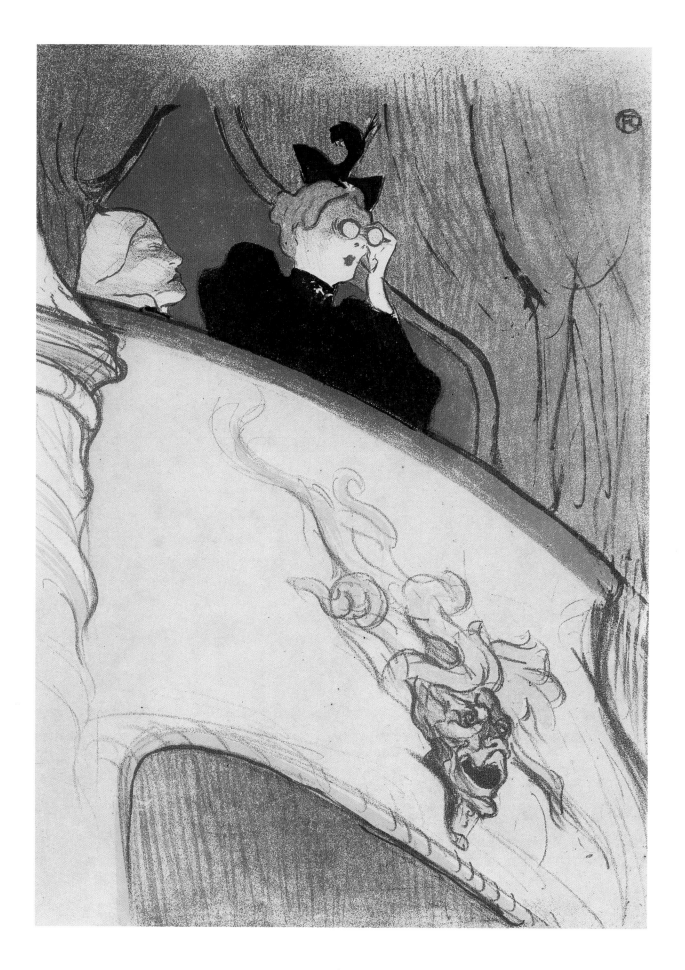

Fig. 43. MISS LOÏE FULLER, *1893. Color lithograph;*
380 x 258 mm. Rogers Fund, 1970 (1970.534)

Fig. 44. Danjuro VII (1791–1859). DANJURO (?) IN A
SHIBARAKU ROLE. *Color woodcut with mica and brass*
powder applied, surimono. The Metropolitan Museum of
Art; Rogers Fund, 1922 (JP 1301)

Nothing sparked Lautrec's artistic activity so much as an entertainer's performance, unless his eye lit upon what he called one of the "side dishes." The artist took particular delight in studying members of the audience, even to the exclusion of the main dramatic production. When French theaters adopted the practice of dimming their houselights in order to fix attention on the stage, he is said to have been distinctly miffed.

The spectacular performance of the American dancer Loïe Fuller depended for its special effects upon a darkened theater that boasted the first electric footlights. Lautrec caught the sight of Miss Fuller tossing her veils in the "fire dance," a hit at the Folies Bergère (fig. 43). In his color lithograph, she is scarcely more than a puff of smoke before ghostly hints of the instruments in the orchestra. So daringly abstract is this portrayal that it could only have been derived from the Japanese—from their images of voluminously costumed Kabuki actors suspended in violent motion and diminutive court ladies overwhelmed by ceremonial robes (fig. 44). Surely the inspiration to apply gold to the picture came from Japanese artists who sometimes enriched their color prints with a sprinkling of mica or powdered brass dust.

Fig. 42. THE BOX WITH THE GILDED MASK, *1894.*
Playbill for Marcel Luguet's LE MISSIONNAIRE. *Color*
lithograph; 502 x 325 mm. Bequest of Scofield Thayer, 1982
(1984.1203.141)

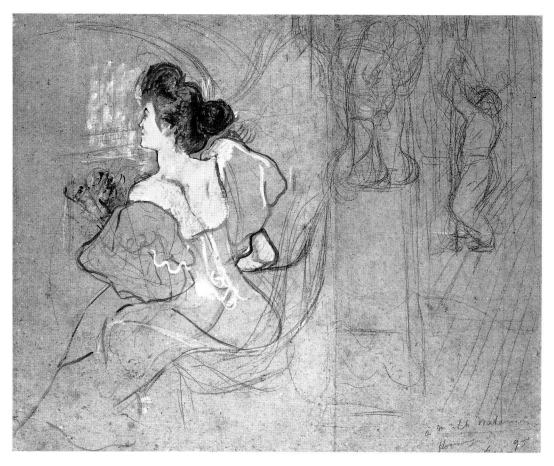

Fig. 45. MADAME THADÉE NATANSON AT THE THEATER, *1895. Study for the cover of the March 1895 issue of* L'ESTAMPE ORIGINALE. *Gouache on cardboard; 622 x 749 mm. Gift of Mr. and Mrs. Richard Rodgers, 1964 (64.153)*

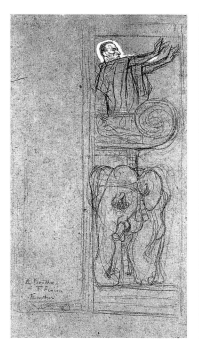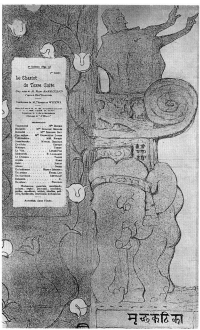

Fig. 46. PRELIMINARY DESIGN FOR THE PLAYBILL TO *LE CHARIOT DE TERRE CUITE, 1895. Blue chalk heightened with white gouache on cardboard; 470 x 280 mm. Promised Gift of Ruth A. Mueller*

Fig. 47. LE CHARIOT DE TERRE CUITE, *1895. Playbill for* THE LITTLE CLAY CART *at the Théâtre de l'Oeuvre. Lithograph; 440 x 282 mm. Promised Gift of Ruth A. Mueller*

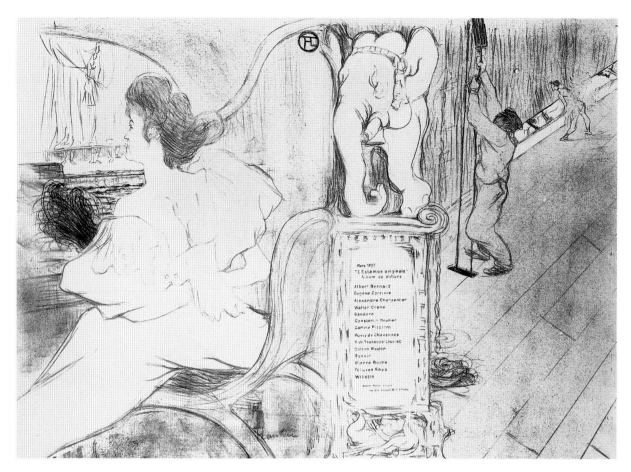

Fig. 48. L'ESTAMPE ORIGINALE, *1895. Cover for a portfolio of prints published by* L'ESTAMPE ORIGINALE (THE ORIGINAL PRINT). *Lithograph; 591 x 845 mm. Rogers Fund, 1922 (22.82.1[81])*

Lautrec designed the playbill (figs. 46, 47) and the final act's stage set for the Indian love story *Le Chariot de terre cuite,* which opened January 22, 1895, at the Théâtre de l'Oeuvre. He also created the book cover for Victor Barrucand's adaptation of the fourth-century drama (fig. 49).

 In these designs, as in the print portfolio he devised for *L'Estampe originale* (figs. 45, 48), Lautrec featured an ornamental elephant, perhaps inspired by the animal rides at the Bois de Boulogne or the papier-mâché model at the Moulin Rouge (fig. 12). On the playbill, the elephant supports the commanding figure of Félix Fénéon, anarchist editor of *La Revue blanche,* who had a bit part in the play. On the print portfolio's cover, the elephant is perched on the stage, across the curtain (and center fold) from young Misia Natanson, wife of the publisher of *La Revue blanche,* shown seated in the audience.

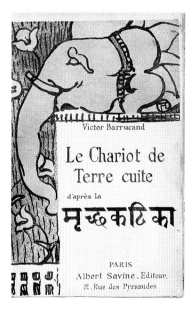

Fig. 49. LE CHARIOT DE TERRE CUITE, *1895. Book cover for* THE LITTLE CLAY CART: A PLAY IN FIVE ACTS BASED ON THE INDIAN DRAMA ATTRIBUTED TO KING SOUDRAKA, *by Victor Barrucand. Lithograph; 85 x 118 mm. The Elisha Whittelsey Collection, The Elisha Whittelsey Fund, 1970 (1970.598.1)*

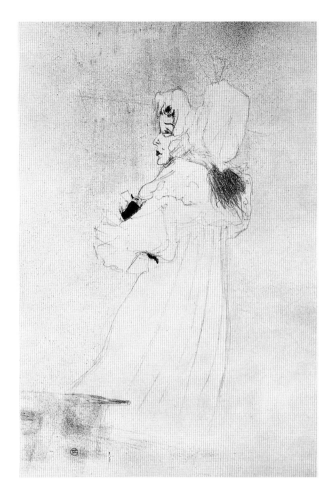

Fig. 50. MISS MAY BELFORT (LARGE PLATE), *1895. Lithograph; 584 x 413 mm. Bequest of Scofield Thayer, 1982 (1984.1203.162)*

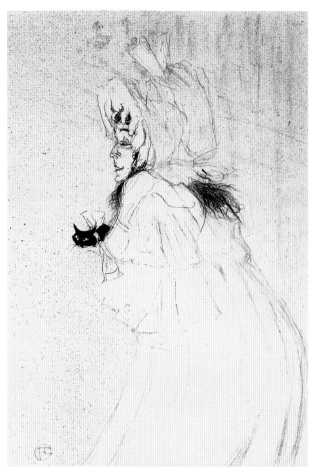

Fig. 51. MISS MAY BELFORT TAKING A BOW, *1895. Lithograph; 556 x 375 mm. The Elisha Whittelsey Collection, The Elisha Whittelsey Fund, 1989 (1989.1120)*

During the late nineteenth century, the French taste for things English extended from horse racing, to tailoring, to nightclub entertainment. Among the popular performers at Le Cabaret des Décadents were the English dancer May Milton and the Irish singer May Belfort, both of whom became Lautrec's models, notably in a pair of posters commissioned to advertise their stage appearances (figs. 54, 23).

May Belfort made a specialty of singing nursery rhymes laced with double entendres in a childish, lisping voice. She delivered her licentious ditties, dressed in a frilly smock and mobcap—the latest in Kate Greenaway style—while wearing a mindless deadpan expression. Between 1895 and 1898 Lautrec

portrayed her in six lithographs, the earliest of which show her from the low vantage point of the audience, sometimes behind musicians who come close to obstructing the view.

Lautrec took a genuine interest in Miss Belfort's star companion, a little black cat which he portrayed both on a Christmas card and on a printed menu he designed for one of the songstress's parties. Expressing particular concern for the animal's welfare, he inquired of Maxime Dethomas: "Miss Belfort is asking around for a husband for her cat. Is your Siamese ready for this business? Drop me a line, if you please, and name a date" (Schimmel 1991, no. 443).

Fig. 52. MISS MAY BELFORT (MEDIUM PLATE), *1895. Lithograph; 546 x 381 mm. Bequest of Scofield Thayer, 1982 (1984.1203.163)*

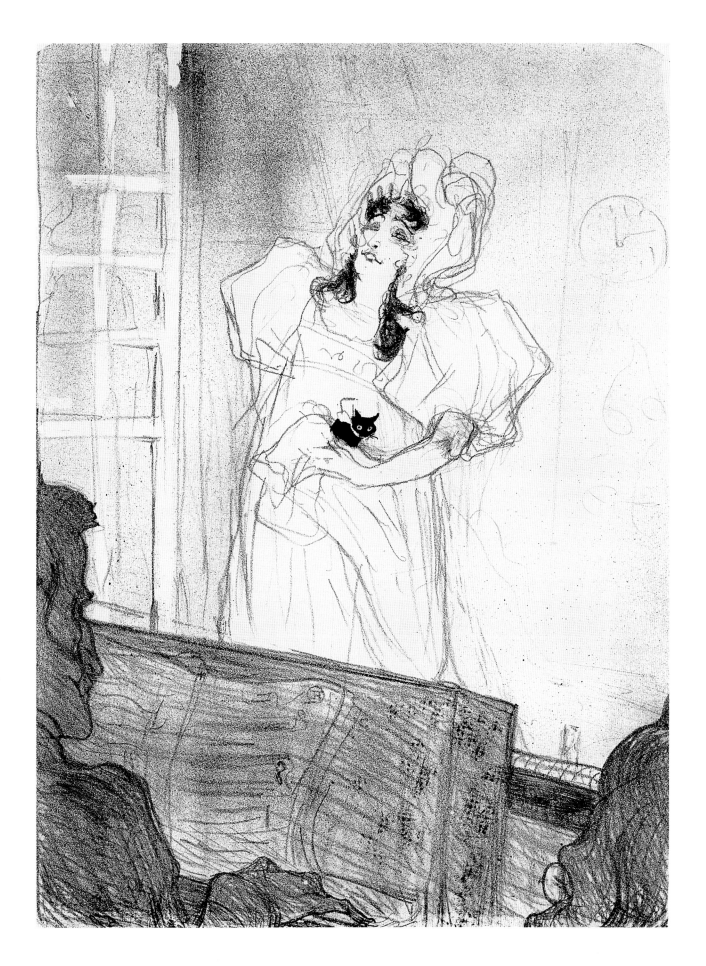

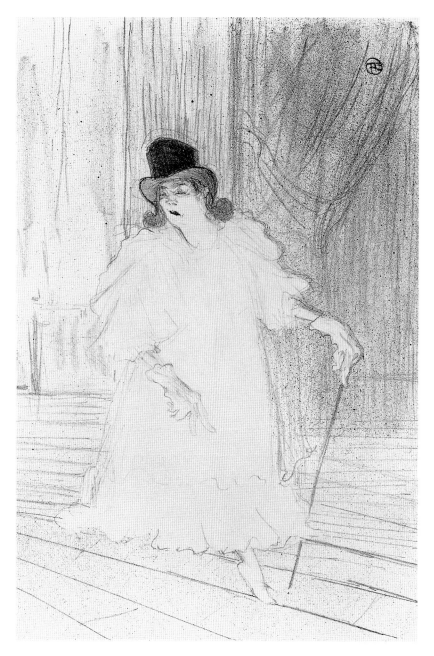

Fig. 53. CECY LOFTUS, *1894. Lithograph; 505 x 340 mm.*
Purchase, Derald H. and Janet Ruttenberg Gift, 1985
(1985.1015)

Solo singers, dancers, and dramatic actors all were
magnets to Lautrec's imagination. He fixed on their
distorted expressions sharpened by makeup and their
quirky gestures enlarged by footlights.

His astute and highly concentrated analysis of a
performer, like the Scottish mimic Cecy Loftus

(fig. 53) or the English dancer May Milton (fig. 54),
usually began with rapid sketches he made while
seated in the audience, observing a star's mobile form
silhouetted against curtained backdrops and the tilted
plane of the stage. The charged atmosphere of the
theater and the dynamics of the performance were
captured in crayon scrawls, spattered ink, and veils of
luminous color. Such wily images as the two shown
here, with their nimble, Daumier-like elasticity, are in
themselves performances, at least as entertaining as
the stage artists' own.

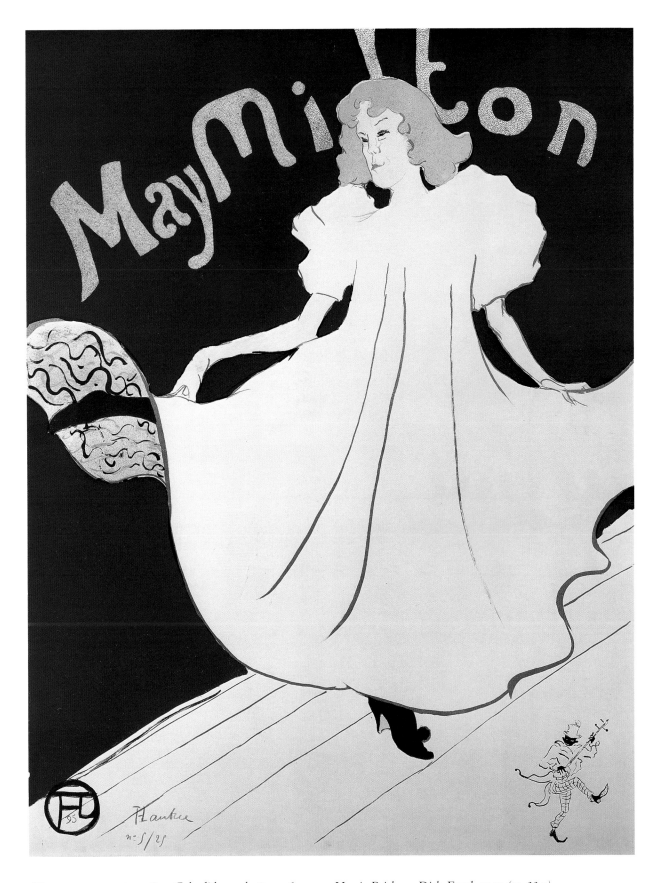

Fig. 54. MAY MILTON, *1895. Color lithograph; 800 x 622 mm. Harris Brisbane Dick Fund, 1932 (32.88.3)*

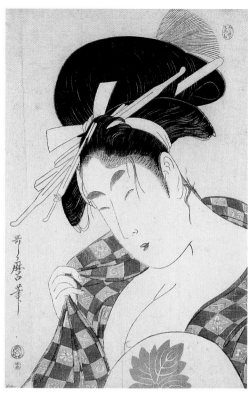

Fig. 55. MADEMOISELLE MARCELLE LENDER, EN BUSTE, *1895. Lithograph, first state; 570 x 390 mm. Harris Brisbane Dick Fund, 1928 (28.81.3)*

Fig. 56. Kitagawa Utamaro (1753–1806). A COURTESAN. *Color woodcut; 373 x 248 mm. The Metropolitan Museum of Art; H. O. Havemeyer Collection, Bequest of Mrs. H. O. Havemeyer, 1929 (JP 1663)*

Lautrec's fascination with Marcelle Lender is revealed in fifteen lithographs and a large oil painting, all done between 1893 and 1895 when, according to *Revue blanche* writer Romain Coolus, Lautrec went to see Lender twenty times in the revival of Hervé's *Chilpéric*. His ambitious portrayals of the star show her as the operetta's Merovingian heroine, Galswinthe, dressed in a low-cut gown with two outlandish pink poppies atop her red hair. The most extravagant of his lithographs, an eight-color production, was distributed in more than a thousand impressions with the Berlin magazine *Pan,* whose editor and art critic, Julius Meier-Graefe, was ultimately dismissed for having published so costly and "decadent" a print.

Mlle Lender's pale, geishalike profile, adorned with a fancy coiffure and richly ornamented textiles reminiscent of the Orient, derives from color woodcuts of courtesans by Kitagawa Utamaro (fig. 56), as does its cropped, close-up format, resembling the bust portraits that became fashionable in Japan about 1790.

Fig. 57. MADEMOISELLE MARCELLE LENDER, EN BUSTE, *1895. Color lithograph, fourth state; 368 x 279 mm. Bequest of Scofield Thayer, 1982 (1984.1203.161)*

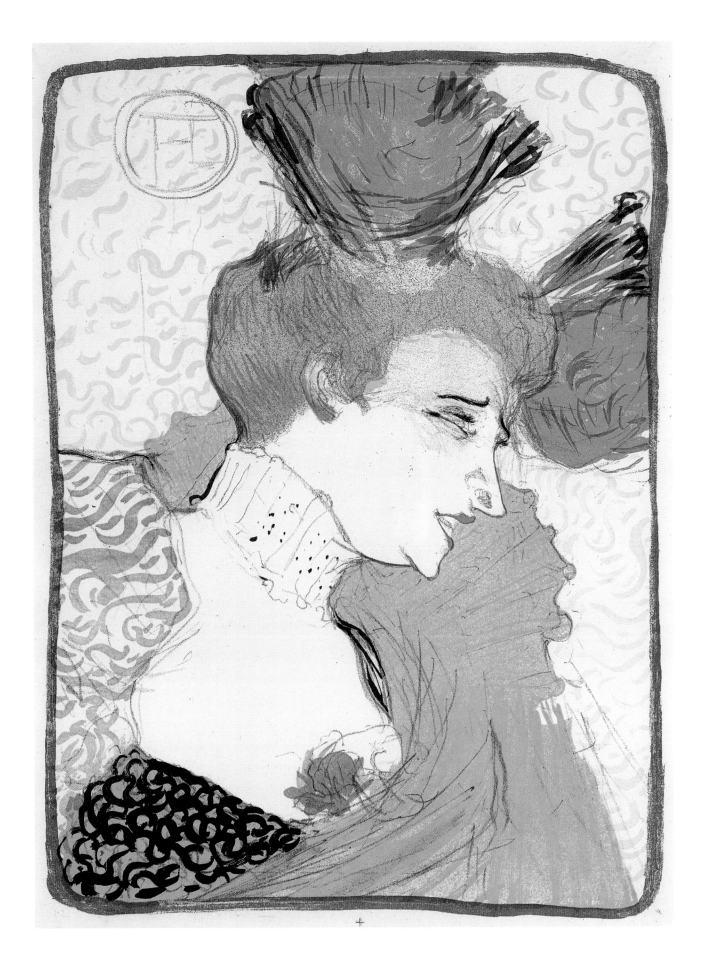

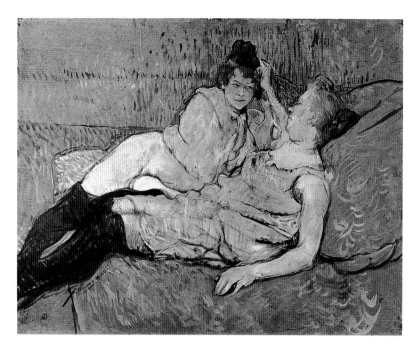

Fig. 58. THE SOFA. *Oil on cardboard; 629 x 810 mm. Rogers Fund, 1951 (51.33.2)*

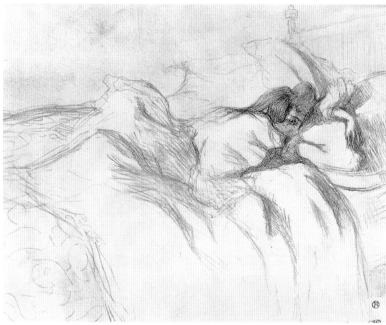

Fig. 59. WAKING UP, *1896. Lithograph, from the series* ELLES; *402 x 522 mm. Bequest of Scofield Thayer, 1982 (1984.1203.166[5])*

Lautrec was always more comfortable in cabarets and brothels than he was in polite company. Thus, he found Montmartre's "houses" agreeable places to lounge with friends, drink, play cards, and find a female companion. He sometimes persuaded the madam to rent him a room, where he was apt to set up his easel for a few days to paint or draw the residents "off duty."

Not particularly shy about exhibiting his paintings of prostitutes publicly, he also devoted a suite of eleven lithographs to *Elles* (Those Women): the often bored and embittered women who lived and worked in the brothels, whose routine activities he reported frankly, as Degas had (so startlingly, but to a more private audience) the decade before.

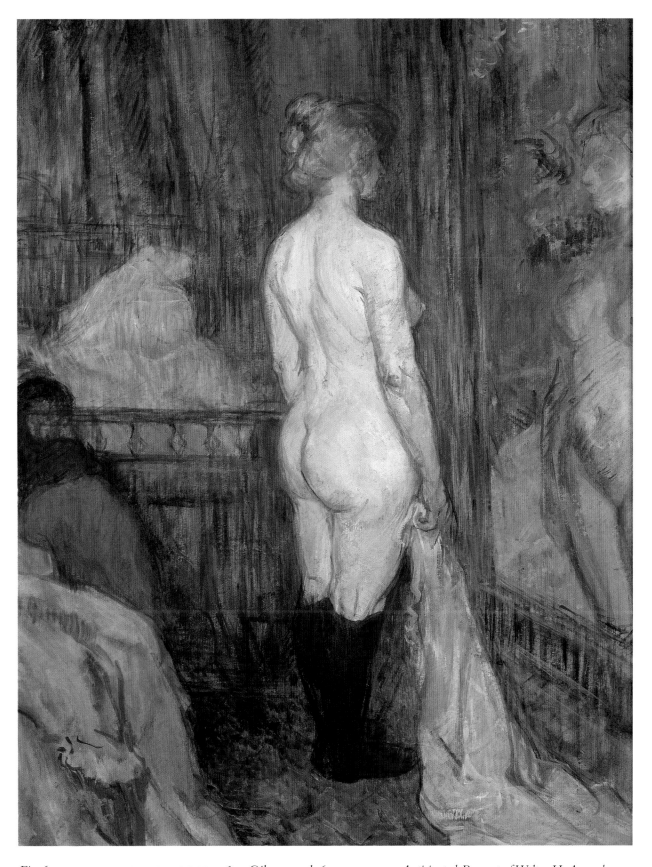

Fig. 60. WOMAN BEFORE A MIRROR, *1897. Oil on wood; 620 x 470 mm. Anticipated Bequest of Walter H. Annenberg*

choisissent les pièces dont ils veulent se donner les représentations de lecture à eux-mêmes, sans décors et sans acteurs, sur la scène de l'imagination.

Pour les autres, l'important, qu'ils l'avouent donc, est de sortir de chez eux où ils s'ennuient, et de s'en aller n'importe où chercher la lumière, le bruit, et la complicité tacite de la foule, des êtres semblables à eux, de la cohue des ennuyés.

En venir là, à cette constatation, c'est en venir, non à la défense du café-concert, — le monstre est vivace, et nul ne défendrait son insolente santé, — mais à la défense, ou plutôt, à l'explication du public du café-concert.

On n'a pas tout dit quand on a dit l'abjection du spectacle, le bas-fond remué, la montée de ruisseau, la débâcle de fange. Le réquisitoire a souvent été fait, et il est facilement fait, il se formule de lui-même.

Mais cette masse riante, qui applaudit les niaiseries et les cochonneries, pourquoi est-elle là ? Tous ces gens qui pourraient donner leurs cinquante sous au Drame, à la Comédie, ou à l'Opéra...

Comment dites-vous cela ?

Quelle erreur est la vôtre ! Ces cinquante sous, ils pourraient les porter ailleurs, mais savez-vous bien à quelles conditions ? Avez-vous réfléchi aux misères et aux vexations de la vie, à tout ce qui poursuit le misérable homme, la pauvre unité sociale, jusque dans ses plaisirs ? Ces cinquante sous, pris sur le nécessaire, sur la paie de la semaine, sur les appointements du mois, sur les bénéfices de la boutique, on n'est pas

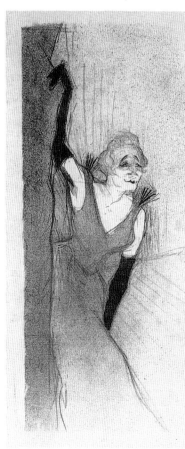

héritée, l'Eglise et la Bourse, le Palais et la Caserne. Mais qui ne consentira, dans l'avenir, à l'effritement et à l'écroulement des monuments, si chacun peut enfin jouir de sa maison et de son jardin, de ses fleurs, de sa ruche et de son arbre ? Le fameux idéal invoqué comporte trop de truffes et de champagne pour les uns, et pas assez même de pain sec pour les autres. Ce sera tout bénéfice pour l'humanité si elle entend et comprend d'une certaine façon ce qui lui sera crié : « Il n'y a pas d'idéal, il y a la soupe et le bœuf, il faut vivre d'abord, créer de la vie, posséder la Terre, lui faire donner son maximum de bonheur. » Ce sera là le commencement de l'action.

Ce sera la conclusion de ces feuilles, si vous le voulez bien. La chanteuse Yvette Guilbert, lorsqu'elle a fini sa chanson, et qu'elle se sauve, la gorge âcre de la fumée respirée, toute sa personne imprégnée de l'atmosphère chaude, où va-t-elle ? Elle saute dans un train, quitte Paris, se rafraîchit à l'air sain de l'espace, retrouve son jardin et sa rivière de Vaux. Humanité tombée au café-concert, fais comme ta chanteuse, aussitôt que tu le pourras, quitte les grandes villes, retourne à la nature avec ce que tu as appris d'histoire et de civilisation, cherche l'ombre de l'arbre, le chant de la branche et du sillon, contente-toi du petit jardin autour duquel il y a l'espace, vis ta propre existence, unis-toi à la Terre enfin dominée par la Pensée.

GUSTAVE GEFFROY.

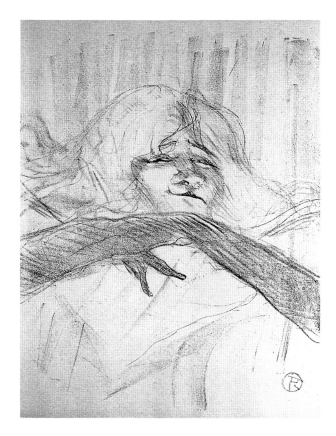

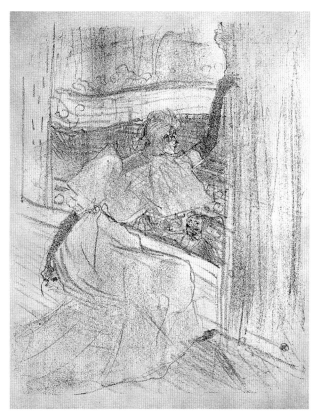

Fig. 63. LINGER LONGER, LOO *(Yvette Guilbert Singing "Linger Longer, Loo"), 1898. Lithograph, seventh in the series* YVETTE GUILBERT*; 499 x 378 mm. Gift of Mrs. H. Wolf, 1917 (17.52[9])*

Fig. 64. SALUANT LE PUBLIC *(Yvette Guilbert Taking a Bow), 1898. Lithograph, eighth in the series* YVETTE GUILBERT*; 559 x 381 mm. Gift of Mrs. H. Wolf, 1917 (17.52[10])*

Two albums of lithographs of Yvette Guilbert, one of sixteen portraits published in 1894 (figs. 61, 62), and the other of eight, published in 1898 (figs. 63, 64), demonstrate the extent to which Lautrec concentrated on a single personality's theatrical performance and conveyed it as a dynamic experience. Mlle Guilbert is shown in a series of unforgettable attitudes and expressions, her lanky black-gloved arms dramatically posed to underscore some bawdy song, her chin thrust out beyond a thin, wry smile.

Having launched her career as a diseuse, speaking rather than truly singing, Guilbert appeared on stage at the Divan Japonais (see fig. 39) and the Moulin Rouge, where Lautrec first saw her in 1890. Although he memorialized her in twenty-nine prints and posters, she had little regard for his work, which she claimed made her "horribly ugly." She reluctantly agreed to add her signature to the 1894 print album in which she was featured, but remarked in exasperation, "Really, Lautrec, you are a genius at deformity" (Yvette Guilbert, *La chanson de ma vie: Mes mémoires* [Paris, 1927], p. 272, quoted in Frey 1994, p. 311).

Figs. 61 and 62. YVETTE GUILBERT, *1894. Lithographs on pages 4 (top) and 16 (bottom), in an album of sixteen lithographs, with text by Gustave Geffroy; each page approx. 381 x 381 mm. Rogers Fund, 1918 (18.31.1)*

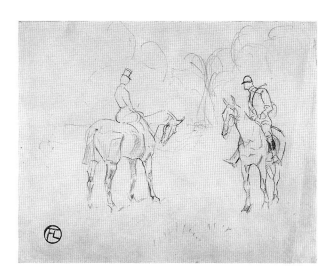

Fig. 65. TWO RIDERS ON HORSEBACK (A WOMAN AND A MAN), *ca. 1879–81. Blue ink and graphite on wove paper; 162 x 200 mm. The Lesley and Emma Sheafer Collection, Bequest of Emma A. Sheafer, 1973 (1974.356.45)*

Fig. 66. EMILIE. *Oil on wood; 413 x 324 mm. The Lesley and Emma Sheafer Collection, Bequest of Emma A. Sheafer, 1973 (1974.356.35)*

Having been raised in a family where riding and hunting were the chief occupations, Lautrec was a lifelong horseman (albeit to a severely limited degree). Even as a child, he perpetually drew his father's dogs and horses and often copied British riding prints.

Near the end of his life, the artist's taste for sporting scenes was apparently revived, and animals regained prominent roles in his pictures. While a patient at the Neuilly clinic of Dr. Sémalaigne, Lautrec was permitted outings to the neighboring Bois de Boulogne where horse races offered diversion. The Longchamp track there may have provided a backdrop for the painting he dedicated to his aunt Emilie (fig. 66). It is surely the locale of the horse race depicted in his lithograph *The Jockey* (fig. 67), which positioned the windmill at the racetrack out in front of the horses, as if it (or drinks at the Moulin Rouge) were the prized goal of the riders. Shown here in an impression before color was added to the surging design, this print is the only one published in a series of racing prints that was commissioned by the publisher Pierrefort.

Fig. 67. THE JOCKEY, *1899. Lithograph, before color; 516 x 360 mm. Harris Brisbane Dick Fund, 1928 (28.81.2)*

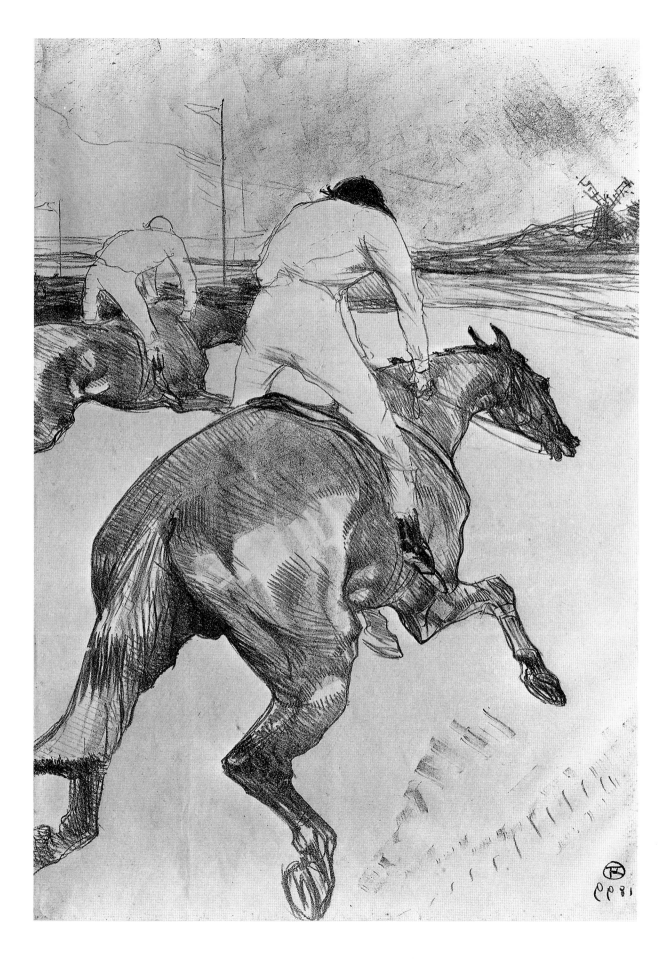

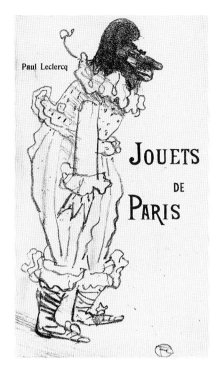

Fig. 69. TWO DOGS. *Pen and brown ink; 75 x 210 mm (margins irregular). Bequest of Grégoire Tarnopol, 1979, and Gift of Alexander Tarnopol, 1980 (1980.21.7)*

Fig. 68. Book cover for JOUETS DE PARIS (TOYS FROM PARIS), *by Paul Leclercq, 1901. Lithograph; 220 x 125 mm. The Elisha Whittelsey Collection, The Elisha Whittelsey Fund, 1970 (1970.598.2)*

Despite the artist's declining health, due largely to his insistent alcoholism and the ravages of syphilis, Lautrec's final works display a remarkably disciplined verve. With untold effort, he kept his wits about him to the end.

During his confinement to the sanitarium in Neuilly, on the outskirts of Paris, Lautrec summoned the strength to produce an ambitious group of color chalk drawings by which he intended to prove his health and sanity to the supervising physicians. These fifty and more sheets, executed in the spring of 1899, display trained animals, clowns, bareback riders, trapeze artists, toe-shoe dancers, a tightrope walker,

a fancy baboon, and other creatures performing in a circus ring, and probably represent metaphorically the artist's view of his own circumscribed situation.

Setting aside their vaguely imbalanced, hallucinatory quality, these prodigiously imaginative images, created entirely from memory and without preliminary sketches, seem to have served their maker well. On May 17, 1899, the doctors confirmed his "physical and mental improvement." As he left the clinic, Lautrec triumphantly remarked, "I've bought my release with my drawings" (Joyant 1926, p. 222, quoted by Roquebert in Frèches-Thory et al. 1991, p. 481).

Fig. 70. AT THE CIRCUS: THE SPANISH WALK, *1899. Black and colored chalks, stumping, and graphite; 350 x 250 mm. Robert Lehman Collection, 1975 (1975.1.731)*

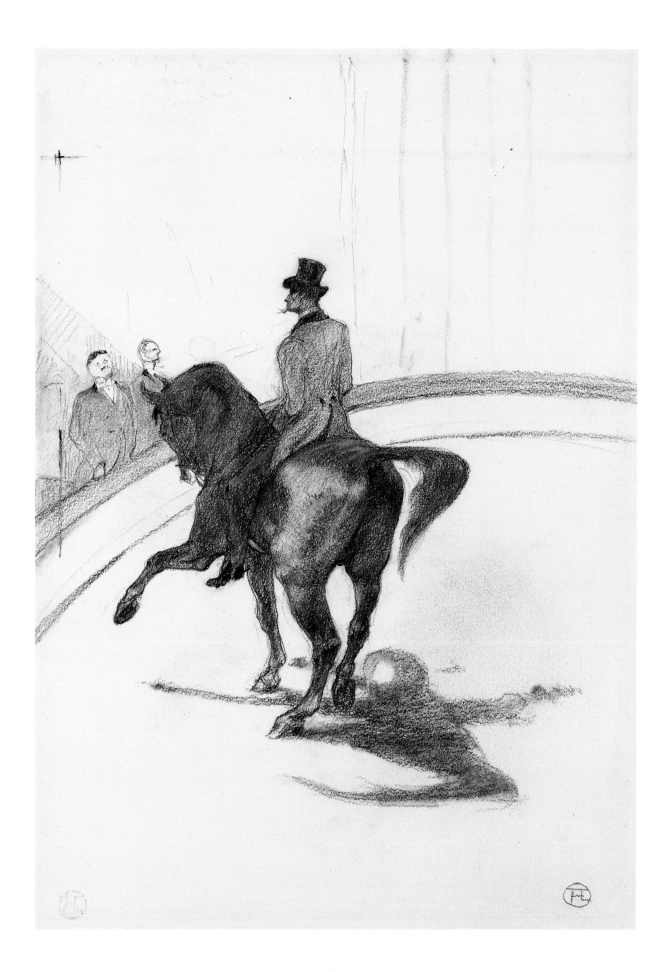

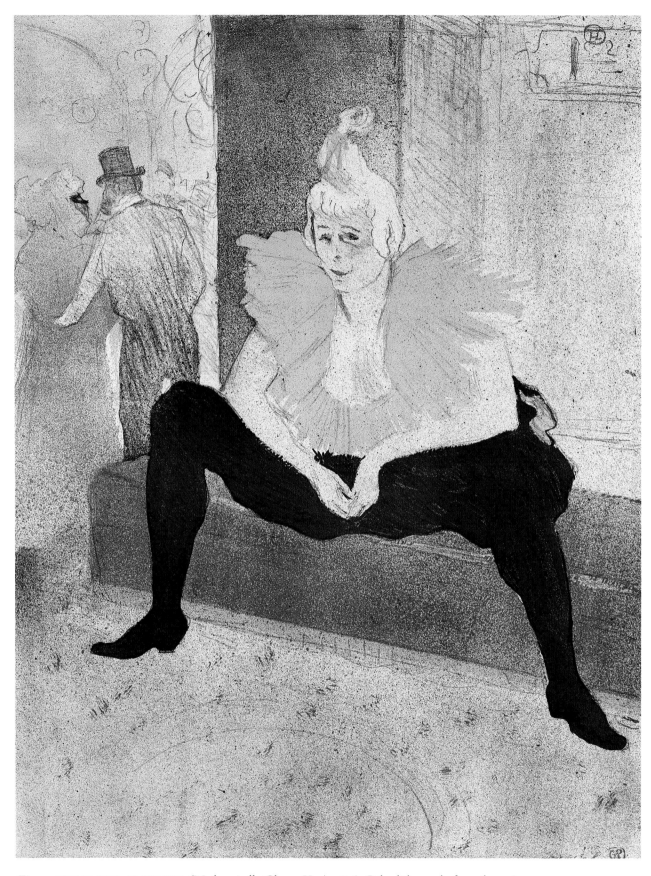

Fig. 71. THE SEATED CLOWNESS *(Mademoiselle Cha-u-Kao), 1896. Color lithograph, from the series* ELLES; *520 x 402 mm. Alfred Stieglitz Collection, 1949 (49.55.50)*

Checklist of the Museum's Paintings, Drawings, and Prints by Toulouse-Lautrec

Figure numbers at the end of entries refer to illustrations in this catalogue. Numbers preceded by the abbreviations Adr., D., or W. are catalogue raisonné listings; citations are given in the Selected Bibliography. Dimensions refer to size of support (canvas, paper, etc.).

Comte Henri-Marie-Raymond
de Toulouse-Lautrec
1864–1901

Paintings

ALBERT (RENÉ) GRENIER, 1887
Oil on wood, 340 x 254 mm
Inscribed (verso): Mon portrait par /
Toulouse Lautrec / en 1887 / atelier rue
Caulaincourt / [Grenier?]
D. P304
Bequest of Mary Cushing Fosburgh, 1978
1979.135.14 (fig. 27)

WOMAN IN THE GARDEN OF
MONSIEUR FOREST
Oil on canvas, 556 x 464 mm
Signed (lower left): HTLautrec
D. P344
Bequest of Joan Whitney Payson, 1975
1976.201.15 (fig. 28)

THE STREETWALKER
Oil on cardboard, 648 x 533 mm
Signed (lower right): HTLautrec
D. P407
Anticipated Bequest of
Walter H. Annenberg (fig. 29)

THE ENGLISHMAN AT THE
MOULIN ROUGE, 1892
Oil and gouache on cardboard,
857 x 660 mm
Signed (lower left): HTLautrec
D. P425; study for a color lithograph
commissioned in 1892
Bequest of Miss Adelaide Milton de Groot
(1876–1967), 1967
67.187.108 (fig. 32)

HENRI-GABRIEL IBELS, 1893
Gouache on paper, 521 x 394 mm
Signed and inscribed (lower right): Pour /
H G IBELS / HTLautrec
D. P463
Anticipated Bequest of
Walter H. Annenberg (fig. 31)

THE SOFA
Oil on cardboard, 629 x 810 mm
Stamped (lower left): HTL [monogram]
D. P601
Rogers Fund, 1951
51.33.2 (fig. 58)

MADAME THADÉE NATANSON
AT THE THEATER, 1895
Gouache on cardboard, 622 x 749 mm
Signed, dated, and inscribed (lower right):
à Meth, Natanson / Hommages de /
HTLautrec 95
D. P599; study for the cover of the March
1895 issue of L'ESTAMPE ORIGINALE
Gift of Mr. and Mrs. Richard Rodgers,
1964
64.153 (fig. 45)

WOMAN BEFORE A MIRROR, 1897
Oil on wood, 620 x 470 mm
Signed and dated (upper left):
HTLautrec '97
D. P637
Anticipated Bequest of
Walter H. Annenberg (fig. 60)

EMILIE
Oil on wood, 413 x 324 mm
Signed and inscribed (lower left):
à Emilie / HTLautrec
D. P675

The Lesley and Emma Sheafer Collection,
Bequest of Emma A. Sheafer, 1973
1974.356.35 (fig. 66)

MADEMOISELLE NYS, 1899
Oil on unprimed wood, 270 x 219 mm
Signed, dated, and inscribed (upper right):
à la famille / Nys / HTLautrec / 1899
D. P680
The Lesley and Emma Sheafer Collection,
Bequest of Emma A. Sheafer, 1973
1974.356.36 (fig. 30)

Drawings

ALBUM DE MARINE, 1879–80
Sketchbook bound in cloth; painted with
oil sketches of the head of the dog Gordon
(front cover), and the bust of an American
sailor (back cover); containing 17
watercolors and 27 black chalk and
graphite sketches in 48 folios;
150 x 235 mm
D. P81–82, A81–97, D900–926
Bequest of Clifford A. Furst, 1958
58.130 (figs. 24, 25)

TWO RIDERS ON HORSEBACK
(A WOMAN AND A MAN), ca. 1879–81
Blue ink and graphite on wove paper,
162 x 200 mm
Stamped in red ink (lower left): HTL
[monogram in a circle] (Lugt 1338)
D. D1182
The Lesley and Emma Sheafer Collection,
Bequest of Emma A. Sheafer, 1973
1974.356.45 (fig. 65)

THE CLOWN: M. JORET, 1885
Pen and black ink (faded to brown),
127 x 102 mm

Signed in ink (lower right): TL
Stamped in red ink (lower left): HTL
[monogram in a circle] (Lugt 1338)
D. D2893
Gift of Mr. and Mrs. Justin K.
Thannhauser, 1951
51.180 (fig. 26)

PRELIMINARY DESIGN FOR THE
PLAYBILL TO *LE CHARIOT DE TERRE
CUITE*, 1895
Blue chalk heightened with white
gouache on cardboard, 470 x 280 mm
Signed in blue chalk (lower left):
En Boudha / à F. Feneon / HTLautrec
D. D3666
Promised Gift of Ruth A. Mueller
 (fig. 46)

TWO DOGS
Pen and brown ink,
75 x 210 mm (margins irregular)
Stamped in brown ink (lower left):
T.N.–H.T.–L. (Madame Thadée Natanson,
Lugt 2449a)
Not in Dortu
Bequest of Grégoire Tarnopol, 1979, and
Gift of Alexander Tarnopol, 1980
1980.21.7 (fig. 69)

AT THE CIRCUS: THE SPANISH WALK
1899
Black and colored chalks, stumping, and
graphite, 350 x 250 mm
Signed in black chalk (lower right): HTL
[monogram in a circle]
Stamped in red ink (lower left): HTL
[monogram in a circle]
D. D4536
Robert Lehman Collection, 1975
1975.1.731 (fig. 70)

Prints

MOULIN ROUGE: LA GOULUE
1891
Poster for the nightclub
Lithograph printed in four colors;
possible edition of 1000–3000
Two sheets of wove paper (top strip
missing): 1680 x 1188 mm
W. P1.A; Adr. 1.I
Bequest of Scofield Thayer, 1982
1984.1203.172
and

Three sheets of wove paper:
1900 x 1165 mm
W. P1.B; Adr. 1.II
Harris Brisbane Dick Fund, 1932
32.88.12 (fig. 2)

AMBASSADEURS: ARISTIDE BRUANT
1892
Poster for Bruant's performance at
Les Ambassadeurs
Lithograph printed in five colors;
possible edition of 1000–3000
Two sheets of wove paper: 1451 x 991 mm
W. P4; Adr. 3
Harris Brisbane Dick Fund, 1932
32.88.11

REINE DE JOIE, 1892
Poster for the book QUEEN OF JOY,
CUSTOMS OF THE DEMIMONDE, by
Victor Joze
Lithograph printed in four colors;
possible edition of 1000–3000
Machine wove paper: 1500 x 995 mm
W. P3; Adr. 5
Harris Brisbane Dick Fund, 1932
32.88.13

AT THE MOULIN ROUGE:
LA GOULUE AND HER SISTER, 1892
Lithograph, printed in six colors;
edition of 100
Machine laid paper: 461 x 348 mm
Signed (lower left): HTLautrec
Stamped (lower right): mark of the printer
Ancourt in red ink
W. 1.II; Adr. 6.II
Gift of Bessie Potter Vonnoh, 1941
41.12.18 (fig. 35)

THE ENGLISHMAN AT THE MOULIN
ROUGE (FLIRT), 1892
Lithograph printed in six colors;
edition of 100
Laid paper: 625 x 485 mm
Signed (lower left): HTLautrec Nº 45
W. 2.II; Adr. 7.II
Gift of Bessie Potter Vonnoh, 1941
41.12.17
and
Laid paper: 625 x 485 mm
Signed (lower left): HTLautrec
Bequest of Scofield Thayer, 1982
1984.1203.138
and
Laid paper: 600 x 480 mm

Signed (lower left): HTLautrec Nº 25
Bequest of Scofield Thayer, 1982
1984.1203.139 (fig. 33)

DIVAN JAPONAIS, 1892/93
Poster for the café concert Japanese Settee
Lithograph printed in four colors;
edition of possibly 1000–3000
Wove paper: 808 x 608 mm
W. P11; Adr. 8
Bequest of Clifford A. Furst, 1958
58.621.17 (fig. 39)

L'ESTAMPE ORIGINALE, PUBLIÉE PAR
LE JOURNAL DES ARTISTES, 1893
Cover for a portfolio of artists' prints
published by L'ESTAMPE ORIGINALE
(THE ORIGINAL PRINT)
Lithograph printed in six colors;
edition of 100
Wove paper with fold at center:
584 x 828 mm
Signed (lower left): HTLautrec / No 73
W. 3; Adr. 9
Rogers Fund, 1922
22.82.1(1) (fig. 41)

MISS LOÏE FULLER, 1893
Lithograph printed in five colors;
edition of ca. 60
Vellum: 380 x 258 mm
W. 17; Adr. 10
Rogers Fund, 1970
1970.534 (fig. 43)

JANE AVRIL, 1893
Poster for the dancer's appearance at the
Jardin de Paris
Lithograph printed in five colors;
edition size unknown
Machine wove paper: 1290 x 935 mm
W. P6.B; Adr. 11.I
Harris Brisbane Dick Fund, 1932
32.88.15 (fig. 1)

ARISTIDE BRUANT,
DANS SON CABARET, 1893
Poster for Bruant's performance
at his cabaret
Lithograph (before text) printed in four
colors; edition size unknown
Machine wove paper: 1395 x 995 mm
W. P9.A; Adr. 12.I
Bequest of Clifford A. Furst, 1958
58.621.19
and

Lithograph (with text) printed in four colors; edition of possibly 1000–3000
Machine wove paper: 1380 x 990 mm
W. P9.C; Adr. 12.II
Harris Brisbane Dick Fund, 1932
32.88.17 (fig. 38)

AU PIED DE L'ECHAFAUD, 1893
Poster for AT THE FOOT OF THE
SCAFFOLD, memoirs of the abbé Faure,
published in the newspaper LE MATIN
(THE MORNING)
Lithograph printed in five colors;
edition of ca. 1000
Machine wove paper: 820 x 603 mm
W. P8; Adr. 14.II
Gift of Bessie Potter Vonnoh, 1941
41.12.9

CAUDIEUX, 1893
Poster
Lithograph printed in four colors;
edition of possibly 1000–3000
Machine wove paper: 1275 x 930 mm
W. P7; Adr. 15
Harris Brisbane Dick Fund, 1932
32.88.14

LE CAFÉ CONCERT, 1893
Suite of eleven lithographs
Published by L'ESTAMPE ORIGINALE in a
portfolio that also included eleven
lithographs by Henri-Gabriel Ibels
Edition of 500 on vellum
W. 18–28; Adr. 16–26
Harris Brisbane Dick Fund, 1923
23.30.3(1–11)
and
Six of Lautrec's eleven lithographs from
the edition of 50 on japan paper
Bequest of Scofield Thayer, 1982
1984.1203.149–154

JANE AVRIL, 1893
Lithograph on vellum: 445 x 314 mm
W. 18; Adr. 16.I
Harris Brisbane Dick Fund, 1923
23.30.3(1) (fig. 40)
and
Japan paper: 457 x 290 mm
Signed (lower left): HTLautrec 11/50
Bequest of Scofield Thayer, 1982
1984.1203.149

(LE CAFÉ CONCERT, continued)
YVETTE GUILBERT, 1893
Lithograph on vellum: 440 x 320 mm
W. 19; Adr. 17
Harris Brisbane Dick Fund, 1923
23.30.3(2)

PAULA BRÉBION, 1893
Lithograph printed in olive green
Vellum: 440 x 320 mm
W. 20; Adr. 18
Bequest of Scofield Thayer, 1982
1984.1203.150
and
Japan paper: 457 x 290 mm
Signed (lower left): HTLautrec 15/50
Harris Brisbane Dick Fund, 1923
23.30.3(3)

MARY HAMILTON, 1893
Lithograph printed in olive green
Vellum: 440 x 320 mm
W. 21; Adr. 19
Harris Brisbane Dick Fund, 1923
23.30.3(4)
and
Japan paper: 457 x 290 mm
Signed (lower left): HTLautrec 17/50
Bequest of Scofield Thayer, 1982
1984.1203.151

EDMÉE LESCOT, 1893
Lithograph on vellum: 440 x 320 mm
W. 22; Adr. 20
Harris Brisbane Dick Fund, 1923
23.30.3(5)

MADAME ABDALA, 1893
Lithograph on vellum: 440 x 320 mm
W. 23; Adr. 21
Harris Brisbane Dick Fund, 1923
23.30.3(6)
and
Japan paper: 463 x 290 mm
Signed (lower right):
HTLautrec / 23/50
Bequest of Scofield Thayer, 1982
1984.1203.152

ARISTIDE BRUANT, 1893
Lithograph on vellum: 440 x 320 mm
W. 24; Adr. 22
Harris Brisbane Dick Fund, 1923
23.30.3(7) (fig. 36)

(LE CAFÉ CONCERT, continued)
CAUDIEUX AT THE PETIT CASINO
1893
Lithograph on vellum: 440 x 320 mm
W. 25; Adr. 23
Harris Brisbane Dick Fund, 1923
23.30.3(8)

DUCARRE AT LES AMBASSADEURS
1893
Lithograph on vellum: 440 x 320 mm
W. 26; Adr. 24
Harris Brisbane Dick Fund, 1923
23.30.3(9)

A SPECTATOR, 1893
Lithograph on vellum: 440 x 320 mm
W. 27; Adr. 25
Harris Brisbane Dick Fund, 1923
23.30.3(10)
and
Japan paper: 463 x 290 mm
Signed (lower right):
HTLautrec / no 20/50
Bequest of Scofield Thayer, 1982
1984.1203.153

ENGLISH COMEDIAN, 1893
Lithograph on vellum: 440 x 320 mm
W. 28; Adr. 26
Harris Brisbane Dick Fund, 1923
23.30.3(11)
and
Japan paper: 463 x 290 mm
Signed (lower right):
HTLautrec / no 8/50
Bequest of Scofield Thayer, 1982
1984.1203.154

LES VIEILLES HISTOIRES, 1893
THE OLD TALES, a suite of ten poems by
Jean Goudezki, set to music by Désiré
Dihau, for which Lautrec designed a cover
and five title pages for nos. 2, 4, 5, 8, and 9
in the series

COVER DESIGN
Lithograph printed in olive green;
proof apart from the edition of ca. 100
printed in black
Vellum: 460 x 616 mm
W. 5.I; Adr. 27.II
The Elisha Whittelsey Collection,
The Elisha Whittelsey Fund, 1949
49.50.269

(*LES VIEILLES HISTOIRES, continued*)

POUR TOI!…
For You!…
Lithograph; edition of 100
Japan paper: 360 x 270 mm
Signed (lower left): no 5 / HTLautrec
W. 6; Adr. 28.I
Bequest of Scofield Thayer, 1982
1984.1203.143
and
Lithograph with stenciled color
Vellum: 270 x 200 mm
Signed (lower left): no 97 / HTLautrec
Bequest of Alexandrine Sinsheimer, 1958
59.534.22

NUIT BLANCHE
Sleepless Night
Lithograph; edition of 100
Mounted vellum: 360 x 270 mm
Signed (lower left): HTLautrec
(erased number: 45?)
W. 8; Adr. 29.I
Bequest of Scofield Thayer, 1982
1984.1203.144
and
Mounted vellum: 360 x 270 mm
Signed (lower left): no 50 / HTLautrec
Alfred Stieglitz Collection, 1949
49.55.151

TA BOUCHE
Your Mouth
Lithograph; edition of 100
Japan paper: 360 x 280 mm
Signed (lower left): no 5 / HTLautrec
W. 7; Adr. 30.I
Bequest of Scofield Thayer, 1982
1984.1203.145
and
Posthumous edition; printed in red
Wove paper: 377 x 276 mm
W. 7; Adr. 30.II
The Elisha Whittelsey Collection,
The Elisha Whittelsey Fund, 1963
63.621.4

ULTIME BALLADE
The Last Ballad
Lithograph; edition of 100
Mounted vellum: 360 x 275 mm
Signed (lower left): no 52 / HTLautrec
W. 10; Adr. 32.I
Bequest of Scofield Thayer, 1982
1984.1203.146
and

(*LES VIEILLES HISTOIRES, continued*)
Lithograph with stenciled color
Vellum: 350 x 272 mm
Signed (lower left): N⁰ 68 / HTLautrec
Alfred Stieglitz Collection, 1949
49.55.153

ETUDE DE FEMME, 1893
Study of a Woman
Lithograph; edition of 100
Japan paper: 360 x 280 mm
Signed (lower left): no 34 / HTLautrec
W. 11; Adr. 33.I
Bequest of Scofield Thayer, 1982
1984.1203.202
and
Mounted vellum: 370 x 277 mm
Signed (lower left): no 34 / HTLautrec
Alfred Stieglitz Collection, 1949
49.55.147

CARNOT MALADE! 1893
Carnot Is Sick!
Lithograph; edition of 100
Japan paper: 347 x 275 mm
Signed (lower left): N 10 / HTLautrec
W. 12; Adr. 34.I
Bequest of Scofield Thayer, 1982
1984.1203.148

CHARLES JULES TRUFFIER AND
MARGUERITE MONCEAU ("MORENO"),
IN *LES FEMMES SAVANTES*, 1893
Lithograph; edition of 50
Vellum: 381 x 283 mm
Stamped (lower left): artist's monogram
in red ink (Lugt 1338)
W. 46; Adr. 38
Alfred Stieglitz Collection, 1949
49.55.148

THE COIFFURE: PLAYBILL FOR THE
THÉÂTRE LIBRE, 1893
Lithograph printed in color; edition of 100
Japan paper: 503 x 330 mm
Signed (lower left): à Kleinmann /
HTLautrec
W. 15.II; Adr. 40.II
Bequest of Scofield Thayer, 1982
1984.1203.140

ANDRÉ ANTOINE AND FERMIN GÉMIER
IN *UNE FAILLITE* (*A BANKRUPTCY*), 1893
Lithograph; edition of 50
Vellum: 381 x 543 mm

Stamped (lower right): artist's monogram
in red ink (Lugt 1338)
W. 43; Adr. 41
Alfred Stieglitz Collection, 1949
49.55.141

JULIA BARTET AND JEAN MOUNET-
SULLY, IN *ANTIGONE* 1893
Lithograph printed in two colors;
edition of 65 impressions
Vellum: 381 x 283 mm
Stamped (lower right):
artist's monogram in red ink (Lugt 1338)
W. 45.II; Adr. 44.II
Alfred Stieglitz Collection, 1949
49.55.331

ILLUSTRATIONS FOR THE WEEKLY
MAGAZINE *L'ESCARMOUCHE,* 1893–94

POURQUOI PAS?…UNE FOIS N'EST
PAS COUTUME, 1893
Why Not?…Once Is Not to Make a
Habit of It
Lithograph printed in olive green
Edition of 100
Japan paper: 464 x 311 mm
Signed (lower left): HTLautrec
W. 30; Adr. 45
Alfred Stieglitz Collection, 1949
49.55.139

EN QUARANTE, 1893
In Their Forties
Lithograph printed in olive green
Proof apart from the edition of 100
Japan paper: 460 x 310 mm
Signed (lower left): HTLautrec
Stamped (lower right): artist's monogram
in red ink (Lugt 1338)
W. 32; Adr. 47
Alfred Stieglitz Collection, 1949
49.55.136

MADEMOISELLE LENDER
AND BARON, 1893
Lithograph printed in sanguine
Proof apart from the edition of 100
Japan paper: 460 x 311 mm
Signed (lower left): HTLautrec
Stamped (lower left): artist's monogram
in red ink (Lugt 1338)
W. 33; Adr. 48
Bequest of Scofield Thayer, 1982
1984.1203.155

(*L'ESCARMOUCHE, continued*)

AU MOULIN ROUGE:
UN RUDE! UN VRAI RUDE! 1893
At the Moulin Rouge:
A Ruffian! A Real Ruffian!
Lithograph
One of three or four known proofs
apart from the edition of 100
Japan paper: 467 x 311 mm
Signed (lower left): HTLautrec
Stamped (lower left): artist's monogram
in red ink (Lugt 1338)
W. 35; Adr. 50
Bequest of Scofield Thayer, 1982
1984.1203.156

A LA RENAISSANCE: SARAH
BERNHARDT DANS *PHÈDRE*, 1893
At the Théâtre de la Renaissance:
Sarah Bernhardt in PHÈDRE
Lithograph; edition of 100
Japan paper: 460 x 311 mm
Signed (lower left): HTLautrec
Stamped (lower left): artist's monogram
in red ink (Lugt 1338)
W. 37; Adr. 52
Bequest of Scofield Thayer, 1982
1984.1203.157
and
Photo mechanical reproduction
of the lithograph, published in
L'ESCARMOUCHE, no. 7,
December 24, 1893
Machine wove paper: 397 x 302 mm
The Elisha Whittelsey Collection,
The Elisha Whittelsey Fund, 1954
54.658.2(7-2)

AU MOULIN ROUGE:
L'UNION FRANCO-RUSSE, 1893
At the Moulin Rouge:
The Franco-Russian Alliance
Lithograph; one of three known proofs
Vellum: 464 x 308 mm
Signed (lower right): HTLautrec
Stamped (lower right): artist's monogram
in red ink (Lugt 1338)
W. 40; Adr. 55
Bequest of Scofield Thayer, 1982
1984.1203.158

BABYLONE D'ALLEMAGNE, 1894
Poster for the book THE GERMAN
BABYLON, by Victor Joze
Lithograph printed in four colors,

before letters
Machine wove paper: 1242 x 875 mm
W. P12.A; Adr. 58.I
Harris Brisbane Dick Fund, 1932
32.88.16

L'ARTISAN MODERNE, 1894
Poster for THE MODERN CRAFTSMAN
Lithograph printed in five colors;
edition of possibly 1000–3000
Machine wove paper: 930 x 650 mm
W. P24.A; Adr. 59.II
Harris Brisbane Dick Fund, 1932
32.88.2

LE PHOTOGRAPHE SESCAU, 1894
The Photographer Sescau
Lithograph printed in four colors
Machine wove paper: 620 x 790 mm
W. P22.B; Adr. 60.II
Harris Brisbane Dick Fund, 1932
32.88.4

RÉJANE AND GALIPAUX, IN *MADAME
SANS-GÊNE,* 1894
Lithograph; edition of 100
Vellum: 308 x 251 mm
Signed (lower left):
Lautrec (by another hand?)
W. 44; Adr. 61
Bequest of Clifford A. Furst, 1958
58.621.4
and
One of five known impressions on
japan paper: 464 x 308 mm
Signed (lower left): HTLautrec
Bequest of Scofield Thayer, 1982
1984.1203.159

CARNAVAL, 1894
Lithograph printed in two colors,
published in LA REVUE BLANCHE, vol. 6,
no. 29 (March 1894); edition of ca. 2000
Vellum: 251 x 162 mm (trimmed)
W. 61.III; Adr. 62.IV
Alfred Stieglitz Collection, 1949
49.55.152

MARTHE BRANDÈS IN HER BOX, 1894
Lithograph printed in dark olive green;
edition of 25
Vellum: 543 x 378 mm
W. 51; Adr. 66
Alfred Stieglitz Collection, 1949
49.55.144

THE BOX WITH THE GILDED MASK, 1894
Designed to decorate the playbill for
Marcel Luguet's LE MISSIONNAIRE
at the Théâtre Libre
Lithograph printed in five colors;
edition of 100
Japan paper: 483 x 325 mm
Signed (lower left): HTLautrec / no 8
W. 16; Adr. 69.I
Alfred Stieglitz Collection, 1949
49.55.146
and
Vellum: 473 x 327 mm
Numbered (lower left): no 51
Bequest of Clifford A. Furst, 1958
58.621.3
and
Japan paper: 502 x 325 mm
Signed and numbered (lower left):
no 12 / HTLautrec
Bequest of Scofield Thayer, 1982
1984.1203.141 (fig. 42)
and
Japan paper: 502 x 325 mm
Signed and numbered (lower left):
no 15 HTLautrec
Bequest of Scofield Thayer, 1982
1984.1203.142

AT LES AMBASSADEURS, 1894
Lithograph printed in six colors
Edition of 100 for L'ESTAMPE ORIGINALE
Vellum: 591 x 410 mm
Signed (lower left): HTLautrec
W. 58; Adr. 70
Rogers Fund, 1922
22.82.1(59)

DANSE EXCENTRIQUE, 1894
Eccentric Dance
Lithograph
Edition of 200 published in the catalogue
of the EXPOSITION DE LA DÉPÊCHE DE
TOULOUSE, Paris, May 15, 1894
Vellum: 175 x 130 mm
W. 60; Adr. 72
The Elisha Whittelsey Collection,
The Elisha Whittelsey Fund, 1963
63.577

YVETTE GUILBERT, 1894
Album of sixteen lithographs printed in
olive green, with text by Gustave Geffroy
Published by L'ESTAMPE ORIGINALE;
edition of 100

Lithograph for cover printed on
japan paper: 406 x 384 mm
Sixteen lithographs on laid paper:
each approx. 381 x 381 mm
W. 69–85; Adr. 73–89.II
Rogers Fund, 1918
18.31.1 (figs. 61, 62)

"LES VIEUX MESSIEURS," 1894
Illustration for the monologue "The Old
Gentlemen," by Maurice Donnay
Lithograph;
first posthumous edition of ca. 45
Wove paper: 527 x 400 mm
Stamped (lower left): artist's monogram
in red ink (Lugt 1338)
W. 57; Adr. 91
Bequest of Clifford A. Furst, 1958
58.621.10

EROS VANNÉ, 1894
Eros Vanquished
Lithograph; edition size unknown
Vellum: 270 x 171 mm
W. 56; Adr. 92.II
The Elisha Whittelsey Collection,
The Elisha Whittelsey Fund, 1965
65.545

ADOLPHE—LE JEUNE HOMME
TRISTE, 1894
Adolphe—The Sad Young Man
Lithograph printed in olive green;
posthumous edition
Vellum: 454 x 308 mm
W. 55; Adr. 93.II
Harris Brisbane Dick Fund, 1928
28.81.1

LA TIGE, MOULIN ROUGE, 1894
The Stalk at the Moulin Rouge
Lithograph; edition of 100
One of three known impressions on
japan paper: 460 x 311 mm
Signed (lower left): HTLautrec
W. 63; Adr. 97
Bequest of Scofield Thayer, 1982
1984.1203.160

IDA HEATH AT THE BAR, 1894
Lithograph; edition of ca. 50
Vellum: 375 x 279 mm
Stamped (lower left): artist's monogram
in red ink (Lugt 1338)
W. 62; Adr. 98

Alfred Stieglitz Collection, 1949
49.55.137

MISS IDA HEATH, ENGLISH DANCER
1894
Lithograph printed in olive green;
edition of 40
Vellum: 375 x 279 mm
Inscribed (lower left):
à Chéret / HTLautrec
W. 64; Adr. 99
Bequest of Clifford A. Furst, 1958
58.621.13

CECY LOFTUS, 1894
Lithograph printed in olive green;
edition of ca. 35
Mounted china paper: 505 x 340 mm
W. 113; Adr. 100
Purchase,
Derald H. and Janet Ruttenberg Gift, 1985
1985.1015 (fig. 53)

CONFETTI, 1894
Poster for J. and E. Bella,
manufacturers of confetti, London
Lithograph printed in three colors;
edition of ca. 1000
Vellum: 568 x 445 mm
W. P13; Adr. 101
Gift of Bessie Potter Vonnoh, 1941
41.12.42 (frontispiece)
and
Vellum: 570 x 442 mm
The Chester Dale Collection,
Bequest of Chester Dale, 1962
63.663.2

LE CHARIOT DE TERRE CUITE, 1895
Playbill for THE LITTLE CLAY CART at
the Théâtre de l'Oeuvre, 1895
Lithograph printed in blue;
edition size unknown
Vellum: 440 x 282 mm
W. 89; Adr. 105.II
Promised Gift of Ruth A. Mueller
 (fig. 47)

LE CHARIOT DE TERRE CUITE, 1895
Book cover for THE LITTLE CLAY CART:
A PLAY IN FIVE ACTS BASED ON THE
INDIAN DRAMA ATTRIBUTED TO KING
SOUDRAKA, by Victor Barrucand
Published by Albert Savine, Paris, 1895
Lithograph; edition size unknown

Vellum: 85 x 118 mm
D. 78.II; not in Wittrock; see Adr. 105
The Elisha Whittelsey Collection,
The Elisha Whittelsey Fund, 1970
1970.598.1 (fig. 49)

LÉONIE YAHNE AND HENRY MAYER,
IN L'AGE DIFFICILE, 1895
Lithograph printed in olive green;
edition of 25
Wove paper: 514 x 394 mm
W. 93; Adr. 107
Bequest of Clifford A. Furst, 1958
58.621.11

LÉONIE YAHNE, 1895
Lithograph printed in olive green;
edition of 25
Wove paper: 543 x 397 mm
Stamped (lower right): artist's monogram
in red ink (Lugt 1338)
W. 91; Adr. 108
Alfred Stieglitz Collection, 1949
49.55.142

MADEMOISELLE MARCELLE LENDER,
EN BUSTE, 1895
Lithograph printed in olive green
One of two known impressions
of the first state
Vellum: 570 x 390 mm
Stamped (twice, on verso):
artist's monogram in red ink (Lugt 1338)
W. 99.I; Adr. 115.I
Harris Brisbane Dick Fund, 1928
28.81.3 (fig. 55)
and
Lithograph printed in eight colors
One of two known proofs
of the fourth state
Vellum: 378 x 279 mm
W. 99.IV; Adr. 115.IVa
Alfred Stieglitz Collection, 1949
49.55.183
and
Lithograph printed in eight colors;
edition of 1100
Published in the German magazine PAN,
vol. 1, no. 3 (1895)
Vellum: 368 x 279 mm
W. 99.IV; Adr. 115.IVb
Alfred Stieglitz Collection, 1949
49.55.163
and

Vellum: 368 x 279 mm
W. 99.IV; Adr. 115.IVb
Bequest of Scofield Thayer, 1982
1984.1203.161 (fig. 57)

MARCELLE LENDER, SEATED, 1895
Lithograph; edition of 20
Wove paper: 511 x 397 mm
Signed (lower left): HTLautrec
W. 102; Adr. 117
Alfred Stieglitz Collection, 1949
49.55.143

MARCELLE LENDER AND EVA
LAVALLIÈRE IN A REVUE AT THE
VARIÉTÉS, 1895
Lithograph printed in olive green;
edition of 20
Vellum: 492 x 349 mm
Stamped (lower right): artist's monogram
in red ink (Lugt 1338)
W. 110; Adr. 119
Harris Brisbane Dick Fund, 1923
23.30.2

MISS MAY BELFORT TAKING A BOW
1895
Lithograph; edition of 65
Vellum: 556 x 375 mm
W. 115; Adr. 121
The Elisha Whittelsey Collection,
The Elisha Whittelsey Fund, 1989
1989.1120 (fig. 51)

MISS MAY BELFORT (LARGE PLATE), 1895
Lithograph; edition of 13
Wove paper: 584 x 413 mm
Stamped (lower right):
artist's monogram in red ink (Lugt 1338)
W. 114.I; Adr. 123.I
Bequest of Scofield Thayer, 1982
1984.1203.162 (fig. 50)

MISS MAY BELFORT
(MEDIUM PLATE), 1895
Lithograph;
one of seven known impressions
Vellum: 546 x 381 mm
Stamped (lower right): monogram of
Roger Marx (Lugt 2229)
W. 117; Adr. 124
Bequest of Scofield Thayer, 1982
1984.1203.163 (fig. 52)

MAY BELFORT, 1895
Poster for the singer's performance at the
Petit Casino
Lithograph printed in four colors
Machine wove paper: 800 x 615 mm
W. P14.B.ii; Adr. 126.IV
Gift of Bessie Potter Vonnoh, 1941
41.12.1 (fig. 23)

L'ESTAMPE ORIGINALE, 1895
Cover for a portfolio of prints
published by L'ESTAMPE ORIGINALE
Lithograph printed in two colors;
edition of 100
Vellum: 591 x 845 mm
Signed (lower center): HTLautrec
W. 96; Adr. 129.III
Rogers Fund, 1922
22.82.1(81) (fig. 48)

LA REVUE BLANCHE, 1895
Poster for the magazine LA REVUE
BLANCHE (THE WHITE REVIEW)
Lithograph printed in four colors;
edition of 1000–3000
Machine wove paper: 1250 x 900 mm
W. P16.C; Adr. 130.III
The Chester Dale Collection,
Bequest of Chester Dale, 1962
63.663.8

LUCE MYRÈS, 1895
Lithograph; one of four impressions
printed in sanguine (apart from the
edition of ca. 30)
Machine laid paper: 515 x 380 mm
W. 121; Adr. 132
Gift of Philip Hofer, 1934
34.81.1

MAY MILTON, 1895
Poster for the dancer's tour of the
United States
Lithograph printed in five colors;
edition of 25
Machine wove paper: 800 x 622 mm
Signed and numbered (lower left):
HTLautrec No. 5/25
W. P17.A; Adr. 134.I
Harris Brisbane Dick Fund, 1932
32.88.3 (fig. 54)
and
Lithograph printed in five colors;
edition of 100
Vellum: 803 x 615 mm

W. P17.B; Adr. 134.II
The Chester Dale Collection,
Bequest of Chester Dale, 1962
63.663.6

NAPOLÉON, 1895
Lithograph printed in six colors;
edition of 100
Vellum: 628 x 487 mm
Signed and numbered (lower left):
HTLautrec no 51
W. 140; Adr. 135
Bequest of Scofield Thayer, 1982
1984.1203.173
and
Vellum: 646 x 496 mm
Signed and numbered (lower left):
HTLautrec no 94
Bequest of Scofield Thayer, 1982
1984.1203.174

SALON DES CENT: EXPOSITION
INTERNATIONALE D'AFFICHES, 1895
The Salon of One Hundred: International
Exhibition of Posters (also known as
THE PASSENGER IN CABIN 54)
Lithograph printed in seven colors;
edition of ca. 1000
Machine wove paper: 605 x 408 mm
W. P20.III; Adr. 137
Gift of Bessie Potter Vonnoh, 1941
41.12.2

LA TROUPE DE MADEMOISELLE
EGLANTINE, 1895/96
Poster for Miss Eglantine's Dance Troupe
Lithograph printed in three colors;
edition of ca. 1000
Machine wove paper: 622 x 803 mm
W. P21.C; Adr. 162.III
Harris Brisbane Dick Fund, 1932
32.88.5

ANNOUNCEMENT FOR THE
THÉÂTRE DE L'OEUVRE, 1895
Lithograph; edition size unknown
Beige wove paper: 245 x 368 mm
W. 143; Adr. 164.II
Gift of Ferdinand H. Davis, 1952
52.554

LA VACHE ENRAGÉE, 1896
The Mad Cow
Lithograph printed in four colors;
possible edition of 1000

Machine wove paper: 827 x 597 mm
W. P27; Adr. 165.III
The Chester Dale Collection,
Bequest of Chester Dale, 1962
63.663.7

THE LEBAUDY TRIAL: MADEMOISELLE
MARSY TESTIFYING, 1896
Lithograph; one of eleven known
impressions in this state
China paper: 475 x 608 mm
W. 152; Adr. 167.II
The Elisha Whittelsey Collection,
The Elisha Whittelsey Fund, 1955
55.558

ELLES, 1896
Those Women
Suite of ten color lithographs
with a title page and portfolio cover
Published by Gustave Pellet, Paris, 1896;
edition of 100
W. 155–165; Adr. 171–181

PORTFOLIO COVER
Lithograph
Japan paper: 683 x 1084 mm
Signed (lower right): TLautrec
Stamped (lower right): publisher's
monogram in purple ink (Lugt 1190)
Inscribed (lower right): Série no 32 GP
(Lugt 1194)
W. 155.I; Adr. 171.I
Alfred Stieglitz Collection, 1949
49.55.140
and
Japan paper: 680 x 1084 mm
Signed (lower right): TLautrec
Stamped (lower right): publisher's
monogram in purple ink (Lugt 1190)
Inscribed (lower right): Série no. 62 GP
(Lugt 1194)
Bequest of Scofield Thayer, 1982
1984.1203.166(1)
and
Japan paper: 597 x 488 mm
Signed (lower right): TLautrec
Stamped (lower right): publisher's
monogram in purple ink (Lugt 1190)
Inscribed (lower right): Série no 9 GP
(Lugt 1194)
Bequest of Scofield Thayer, 1982
1984.1203.168

(*ELLES, continued*)
TITLE PAGE
Lithograph printed in three colors
Wove paper: 525 x 404 mm
Inscribed (lower right): Série no 30 GP
(Lugt 1194)
Stamped (lower right): publisher's
monogram in purple ink (Lugt 1190)
W. 155.II; Adr. 171.II
Alfred Stieglitz Collection, 1949
49.55.49
and
Wove paper: 520 x 402 mm
Inscribed (lower right): série no 32 GP
(Lugt 1194)
Stamped (lower right): publisher's
monogram in purple ink (Lugt 1190)
Bequest of Scofield Thayer, 1982
1984.1203.166(2)

POSTER
Announcement of an exhibition of
ELLES at the offices of the magazine
LA PLUME, Paris, April 22, 1896
Lithograph printed in four colors
Vellum: 612 x 470 mm
W. 155.III; Adr. 171.IV
Bequest of Clifford A. Furst, 1958
58.621.16
and
Vellum: 612 x 497 mm
Bequest of Scofield Thayer, 1982
1984.1203.167

THE SEATED CLOWNESS, 1896
(Mademoiselle Cha-u-Kao)
Lithograph printed in five colors
Wove paper: 520 x 402 mm
Inscribed (lower right): Série no 30 GP
(Lugt 1194)
Stamped (lower right): publisher's
monogram in purple ink (Lugt 1190)
W. 156; Adr. 172
Alfred Stieglitz Collection, 1949
49.55.50 (fig. 71)
and
Wove paper: 522 x 401 mm
Inscribed (lower right): Série no 62 GP
(Lugt 1194)
Bequest of Scofield Thayer, 1982
1984.1203.166(3)

SERVING BREAKFAST, 1896
(Madame Baron and Mademoiselle Popo)
Lithograph printed in sanguine

(*ELLES, continued*)
Wove paper: 402 x 520 mm
Stamped (lower right): publisher's
monogram in purple ink (Lugt 1190)
Inscribed (lower right): Série no 32 GP
(Lugt 1194)
W. 157; Adr. 173
Alfred Stieglitz Collection, 1949
49.55.51
and
Wove paper; 401 x 522 mm
Inscribed (lower right): Série no 62 GP
(Lugt 1194)
Bequest of Scofield Thayer, 1982
1984.1203.166(4)

WAKING UP, 1896
Lithograph printed in drab green
Wove paper: 410 x 522 mm
Stamped (lower right): publisher's
monogram in purple ink (Lugt 1190)
Inscribed (lower right): Série no′ 30 GP
(Lugt 1194)
W. 158; Adr. 174
Alfred Stieglitz Collection, 1949
49.55.52
and
Wove paper: 402 x 522 mm
Inscribed (lower right): Série no 62 GP
(Lugt 1194)
Bequest of Scofield Thayer, 1982
1984.1203.166(5) (fig. 59)

FILLING A TUB, 1896
Lithograph printed in five colors
Wove paper: 403 x 523 mm
Inscribed (lower right): Série no 51 GP
(Lugt 1194)
Stamped (lower right): publisher's
monogram in purple ink (Lugt 1190)
W. 159; Adr. 175
Alfred Stieglitz Collection, 1949
49.55.53
and
Wove paper: 401 x 522 mm
Inscribed (lower right): Série no 62 GP
(Lugt 1194)
Bequest of Scofield Thayer, 1982
1984.1203.166(6)

WASHING, 1896
Lithograph printed in two colors
Wove paper: 522 x 402 mm
Inscribed (lower right): Série no 30 GP
(Lugt 1194)

Stamped (lower right): publisher's
monogram in purple ink (Lugt 1190)
W. 160; Adr. 176
Alfred Stieglitz Collection, 1949
49.55.54
and
Wove paper: 519 x 400 mm
Inscribed (lower right): Série 62 GP
(Lugt 1194)
Bequest of Scofield Thayer, 1982
1984.1203.166(7)
and
Wove paper: 524 x 402 mm
Stamped (lower right): publisher's
monogram in red ink (Lugt 1190)
Bequest of Scofield Thayer, 1982
1984.1203.169

LOOKING IN A MIRROR, 1896
Lithograph printed in three colors
Wove paper: 520 x 401 mm
Stamped (lower right): publisher's
monogram in purple ink (Lugt 1190)
Inscribed (lower right): Série no 30 GP
(Lugt 1194)
W. 161; Adr. 177
Alfred Stieglitz Collection, 1949
49.55.55
and
Wove paper: 520 x 400 mm
Inscribed (lower right): Série no 62 GP
(Lugt 1194)
Bequest of Scofield Thayer, 1982
1984.1203.166(8)

COMBING HAIR, 1896
Lithograph printed in two colors
Wove paper: 523 x 403 mm
Inscribed (lower right): Série no 32 GP
(Lugt 1194)
Stamped (lower right): publisher's
monogram in purple ink (Lugt 1190)
W. 162; Adr. 178
Alfred Stieglitz Collection, 1949
49.55.56
and
Wove paper: 520 x 405 mm
Inscribed (lower right): Série no 62 GP
(Lugt 1194)
Bequest of Scofield Thayer, 1982
1984.1203.166(9)
and
Wove paper: 520 x 403 mm

Inscribed (lower right): Série no 13 GP
(Lugt 1194)
Stamped (lower right): publisher's
monogram in purple ink (Lugt 1190)
Bequest of Scofield Thayer, 1982
1984.1203.170

GETTING UP, 1896
Lithograph printed in four colors
Wove paper: 404 x 520 mm
Inscribed (lower right): Série no 30 GP
(Lugt 1194)
Stamped (lower right): publisher's
monogram in purple ink (Lugt 1190)
W. 163; Adr. 179.III
Alfred Stieglitz Collection, 1949
49.55.57
and
Wove paper: 403 x 522 mm
Inscribed (lower right): Série no 62 GP
(Lugt 1194)
Bequest of Scofield Thayer, 1982
1984.1203.166(10)

FASTENING A CORSET, 1896
Lithograph printed in five colors
Wove paper: 525 x 405 mm
Inscribed (lower right): Série no 30 GP
(Lugt 1194)
Stamped (lower right): publisher's
monogram in purple ink (Lugt 1190)
W. 164; Adr. 180
Alfred Stieglitz Collection, 1949
49.55.58
and
Wove paper: 525 x 405 mm
Stamped (lower left): artist's monogram
in blue ink (Lugt 1338)
Inscribed (lower right): Série no 62 GP
(Lugt 1194)
Bequest of Scofield Thayer, 1982
1984.1203.166(11)

COLLAPSED ON THE BED, 1896
Lithograph printed in two colors
Wove paper: 402 x 523 mm
Inscribed (lower right): Série no 30 GP
(Lugt 1194)
Stamped (lower right): publisher's
monogram in purple ink (Lugt 1190)
W. 165; Adr. 181
Alfred Stieglitz Collection, 1949
49.55.59
and

Wove paper: 402 x 523 mm
Inscribed (lower right): Série no 62 GP
(Lugt 1194)
Bequest of Scofield Thayer, 1982
1984.1203.166(12)
and
Wove paper: 402 x 523 mm
Inscribed (lower right): Série no 7 GP
(Lugt 1194)
Stamped (lower right): publisher's
monogram in purple ink (Lugt 1190)
Bequest of Scofield Thayer, 1982
1984.1203.171

DÉBAUCHÉ, 1896
The Debaucher
Lithograph printed in three colors;
edition of 50
Vellum: 383 x 560 mm
Signed (lower left): HTLautrec
Inscribed (lower right): 24/50 Arn
(abbreviation for publisher Arnould)
W. 167.II; Adr. 187.II
Bequest of Scofield Thayer, 1982
1984.1203.165

FIVE O'CLOCK: SUPPER IN LONDON,
1896
Lithograph; edition of 100
Vellum: 345 x 475 mm
Signed (lower left): HTLautrec
Inscribed (lower center): Fife (*sic*) o'clock
W. 169; Adr. 192
Bequest of Scofield Thayer, 1982
1984.1203.164

AU PIED DU SINAÏ, 1897
Book cover for **AT THE FOOT OF SINAI**,
by Georges Clemenceau
Lithograph printed in five colors
Unfolded proof before the edition of 405
Vellum: 378 x 562 mm
W. 188; Adr. 213.II
Bequest of Clifford A. Furst, 1958
58.621.1

YVETTE GUILBERT, 1898
Portfolio of eight lithographs,
with a frontispiece and a cover
Text by Arthur Byl
Translation by A. Texeira de Mattos
Published by Bliss, Sands & Co.,
London, 1898; edition of 350

W. 271–279; Adr. 250–258
Gift of Mrs. H. Wolf, 1917
17.52(1–10)

COVER
Yvette Guilbert
Blue wove paper: 546 x 419 mm
W. 272; Adr. 251.III
Gift of Mrs. H. Wolf, 1917
17.52(1)

FRONTISPIECE
Yvette Guilbert before the
Prompter's Box
Laid paper: 502 x 378 mm
W. 271; Adr. 250
Gift of Mrs. H. Wolf, 1917
17.52(2)

I. SUR LA SCÈNE
Yvette Guilbert on Stage
Lithograph printed with
beige tint stone
Laid paper: 499 x 378 mm
W. 272; Adr. 251.II
Gift of Mrs. H. Wolf, 1917
17.52(3)

II. DANS LA GLU
Yvette Guilbert Singing "Fallen for It"
Lithograph printed with
beige tint stone
Laid paper: 511 x 384 mm
W. 273; Adr. 252.II
Gift of Mrs. H. Wolf, 1917
17.52(4)

III. PESSIMA
Yvette Guilbert in PESSIMA
Lithograph printed with
beige tint stone
Laid paper: 473 x 378 mm
W. 274; Adr. 253.II
Gift of Mrs. H. Wolf, 1917
17.52(5)

IV. A MÉNILMONTANT DE BRUANT
Yvette Guilbert Singing "At
Ménilmontant" by Aristide Bruant
Lithograph printed with
beige tint stone
Laid paper: 502 x 378 mm
W. 275; Adr. 254.II
Gift of Mrs. H. Wolf, 1917
17.52(6)

(*YVETTE GUILBERT, continued*)
V. CHANSON ANCIENNE
Yvette Guilbert: An Old Song
Lithograph printed with
beige tint stone
Laid paper: 565 x 381 mm
W. 276; Adr. 255.II
Gift of Mrs. H. Wolf, 1917
17.52(7)

VI. SOULARDE
Yvette Guilbert Singing "The Drinker"
Lithograph printed with
beige tint stone
Laid paper: 502 x 378 mm
W. 277; Adr. 256.II
Gift of Mrs. H. Wolf, 1917
17.52(8)

VII. LINGER LONGER, LOO
Yvette Guilbert Singing "Linger
Longer, Loo"
Lithograph printed with
beige tint stone
Laid paper: 499 x 378 mm
W. 278; Adr. 257.II
Gift of Mrs. H. Wolf, 1917
17.52(9) (fig. 63)

VIII. SALUANT LE PUBLIC
Yvette Guilbert Taking a Bow
Lithograph printed with
beige tint stone
Laid paper: 559 x 381 mm
W. 279; Adr. 258.II
Gift of Mrs. H. Wolf, 1917
17.52(10) (fig. 64)

TREIZE LITHOGRAPHIES, 1898
PORTRAITS OF ACTORS AND ACTRESSES
Portfolio of thirteen lithographs
(this set missing four)
Published in Paris, ca. 1901–6;
edition of ca. 400
China paper: each approx. 387 x 314 mm
W. 249–261; Adr. 260–272
Alfred Stieglitz Collection, 1949
49.55.138, 49.55.154–162, and 49.55.328

SARAH BERNHARDT
W. 249; Adr. 260
Alfred Stieglitz Collection, 1949
49.55.162

(*TREIZE LITHOGRAPHIES, continued*)
SYBIL SANDERSON
W. 257; Adr. 261
Alfred Stieglitz Collection, 1949
49.55.161

CLÉO DE MÉRODE
W. 258; Adr. 262
Alfred Stieglitz Collection, 1949
49.55.160

COQUELIN AÎNÉ
The Old Coquelin
W. 254; Adr. 263
Alfred Stieglitz Collection, 1949
49.55.157

LUCIEN GUITRY
W. 259; Adr. 265
Alfred Stieglitz Collection, 1949
49.55.158

MARIE-LOUISE MARSY
W. 260; Adr. 268
Alfred Stieglitz Collection, 1949
49.55.156

POLIN
W. 261; Adr. 269
Alfred Stieglitz Collection, 1949
49.55.155

MAY BELFORT
W. 252; Adr. 270
Alfred Stieglitz Collection, 1949
49.55.154
and
China paper: 292 x 241 mm (trimmed
impression with title printed in green
on the green linen portfolio cover)
Alfred Stieglitz Collection, 1949
49.55.328

JANE HADING
W. 255; Adr. 272
Alfred Stieglitz Collection, 1949
49.55.159
and
Brown-green laid paper: 467 x 311 mm
Alfred Stieglitz Collection, 1949
49.55.138

MADAME RÉJANE, 1898
Lithograph; posthumous impression,
possibly from the 1936 edition of 75

Wove paper: 475 x 330 mm
W. 266; Adr. 275
Bequest of Clifford A. Furst, 1958
58.621.2

THE MOTOGRAPH MOVING
PICTURE BOOK, 1898
Cover for the book illustrated by
F. J. Verny, Yorick, and others
Published by Bliss, Sands & Co.,
London, 1898
Mechanical reproduction of a drawing
by Lautrec; edition size unknown
Vellum: 295 x 225 mm
See Dortu 4442–4444
The Elisha Whittelsey Collection,
The Elisha Whittelsey Fund, 1965
65.657

L'EXEMPLE DE NINON DE LENCLOS,
AMOUREUSE, 1898
Book cover for NINON DE LENCLOS
IN LOVE, by Jean de Tinan
Lithograph; edition of 500
Published by MERCURE DE FRANCE,
Paris, 1898
Vellum: front and back covers,
each 185 x 120 mm
W. 288; Adr. 292.II
The Elisha Whittelsey Collection,
The Elisha Whittelsey Fund, 1970
1970.672

AT THE BRASSERIE HANNETON, 1898
Lithograph printed in black-brown;
edition of 100
Wove paper: 475 x 350 mm
Signed (lower right): HTLautrec
Stamped (lower right):
artist's monogram in red ink (Lugt 1338)
W. 296; Adr. 303
Alfred Stieglitz Collection, 1949
49.55.145

THE MASTER PRINTMAKER:
ADOLPHE ALBERT, 1898
Lithograph printed in black; edition of 100
Wove paper: 473 x 350 mm
Signed (lower left): HTLautrec
Stamped (lower left):
artist's monogram in red ink (Lugt 1338)
W. 297; Adr. 304
Bequest of Clifford A. Furst, 1958
58.621.8

GUY AND MEALY, IN PARIS QUI
MARCHE, 1898
Lithograph printed in dark violet;
edition of 100
Japan paper: 397 x 289 mm
Signed (lower left): HTLautrec
W. 295; Adr. 305
Alfred Stieglitz Collection, 1949
49.55.150

THE JOCKEY, 1899
Lithograph; edition ca. 100
China paper: 516 x 360 mm

W. 308.II; Adr. 345.I
Harris Brisbane Dick Fund, 1928
28.81.2 (fig. 67)

LOUISE BLOUET "LE MARGOIN," 1900
Lithograph; edition of 40
Vellum: 478 x 353 mm
W. 334; Adr. 356
Bequest of Clifford A. Furst, 1958
58.621.12

A SCENE FROM OFFENBACH'S
LA BELLE HÉLÈNE, 1900
Lithograph; edition of ca. 30
Vellum: 712 x 525 mm
Stamped (lower right):
artist's monogram in red ink (Lugt 1338)
W. 331; Adr. 358
Harris Brisbane Dick Fund, 1923
23.30.1

JOUETS DE PARIS, 1901
Book cover for TOYS FROM PARIS,
by Paul Leclercq
Lithograph; edition of 300
Published by Librairie de la Madeleine,
Paris, 1901
Vellum: 220 x 125 mm
Book numbered: 269/300
W. 332; Adr. 359.III
The Elisha Whittelsey Collection,
The Elisha Whittelsey Fund, 1970
1970.598.2 (fig. 68)

Selected Bibliography

Adriani, Götz. *Toulouse-Lautrec.* London and New York: Thames and Hudson, 1987.

Adr.
Adriani, Götz. *Toulouse-Lautrec, the Complete Graphic Works: A Catalogue Raisonné, the Gerstenberg Collection.* London: Thames and Hudson, 1988.

Baetjer, Katharine. *European Paintings in The Metropolitan Museum of Art by Artists Born before 1865: A Summary Catalogue.* New York: Metropolitan Museum of Art, 1995.

Bailey, Colin B.; Joseph J. Rishel; and Mark Rosenthal. *Masterpieces of Impressionism and Post-Impressionism: The Annenberg Collection.* Philadelphia: Philadelphia Museum of Art, 1989.

Castleman, Riva, and Wolfgang Wittrock, eds. *Henri de Toulouse-Lautrec: Images of the 1890s.* New York: Museum of Modern Art, 1985.

Catalogue Musée Toulouse-Lautrec. Albi, 1985.

Cate, Phillip Dennis, and Patricia Eckert Boyer. *The Circle of Toulouse-Lautrec: An Exhibition of the Work of the Artist and His Close Associates.* New Brunswick, N. J.: Jane Voorhees Zimmerli Art Museum, Rutgers University Press, 1985.

Cooper, Douglas. *Henri de Toulouse-Lautrec.* New York: Abrams, 1982.

Delteil, Loys. *Le peintre-graveur illustré.* Vols. 10, 11. *H. de Toulouse-Lautrec.* Paris: Chez l'Auteur, 1920.

Dortu, M. G. Introduction to *Toulouse-Lautrec: Album de Marine.* Facsimile edition. Paris: Berggruen et Cie, 1953.

D.
Dortu, M. G. *Toulouse-Lautrec et son oeuvre: Catalogue des peintures, aquarelles, monotypes, reliure, vitrail, céramique, dessins.* 6 vols. New York: Collectors Editions, 1971.

Frèches-Thory, Claire; Anne Roquebert; Richard Thomson; and Danièle Devynck. *Toulouse-Lautrec.* New Haven and London: Yale University Press, 1991.

Frey, Julia. *Toulouse-Lautrec: A Life.* New York: Viking, 1994.

Goldschmidt, Lucien, and Herbert Schimmel, eds. *Unpublished Correspondence of Henri de Toulouse-Lautrec.* London: Phaidon, 1969. Revised French edition, *Toulouse-Lautrec. Lettres, 1871–1901.* Paris: Gallimard, 1972.

Ives, Colta. *The Great Wave: The Influence of Japanese Woodcuts on French Prints.* New York: Metropolitan Museum of Art, 1974.

Ives, Colta. *French Prints in the Era of Impressionism and Symbolism. Metropolitan Museum of Art Bulletin* 46, no. 1 (Summer 1988).

Joyant, Maurice. *Henri de Toulouse-Lautrec, 1864–1901.* Vol. 1, *Peintre.* Paris: H. Floury, 1926. Vol. 2, *Dessins, estampes, affiches.* Paris: H. Floury, 1927.

Lugt, Frits. *Les marques de collections de dessins et d'estampes....* Amsterdam: Vereenigde, 1921. *Supplément.* The Hague: M. Nijhoff, 1956.

Murray, Gale. *Toulouse-Lautrec: The Formative Years, 1878–1891.* Oxford: Clarendon Press, 1991.

Schimmel, Herbert D., ed. *The Letters of Henri de Toulouse-Lautrec.* Oxford and New York: Oxford University Press, 1991.

Thomson, Richard. *Toulouse-Lautrec.* London: Oresko Books, 1977.

W.
Wittrock, Wolfgang. *Toulouse-Lautrec: The Complete Prints.* 2 vols. London: Philip Wilson Publishers, 1985.